IMA
of Ar

HIST
DALLAS PARKS

4/15

ON THE COVER: Around 1930, children participate in a footrace at Trinity Play, which opened in 1909. It was located on Cockrell Street in what was then known as the Cotton Mills District and catered to the children of mill workers. (03-002.)

IMAGES
of America

HISTORIC
DALLAS PARKS

John H. Slate and the
Dallas Municipal Archives

ARCADIA
PUBLISHING

Printed in the United States of America

Library of Congress Control Number: 2009942099

For all general information contact Arcadia Publishing at:
Telephone 843-853-2070
Fax 843-853-0044
E-mail sales@arcadiapublishing.com
For customer service and orders:
Toll-Free 1-888-313-2665

Visit us on the Internet at www.arcadiapublishing.com

*To all past and present pack rat employees of the City of Dallas
and far-sighted citizens who knew it was right to save things
that might later have historic significance. Thank you.*

CONTENTS

ACKNOWLEDGMENTS

With few noted exceptions, all images are found in the following collections of the Dallas Municipal Archives:

02-011 Dallas Park and Recreation Department Plans and Drawings
91-001 John F. Kennedy/Dallas Police Department Collection
03-002 Park and Recreation Department Photographs
91-060 Dallas Water Utilities Photographs
95-023 Park and Recreation Department of General Subject Files
91-004 Kessler Plan Collection
95-025 Dallas Park Board Annual Reports
01-003 Love Field Album and Photographs
03-015 Report on the Dallas Park System (1934)
02-007 Fair Park Mural Conservation
92-018 Portraits of Park Board Members
95-030 Everette DeGolyer Estate
95-031 W. W. Samuell Estate
95-043 Parks—Works Progress Administration Records
96-003 Park Department Centennial History Collection
99-003 City Photographer Collection
06-004 Public Works and Transportation Department Plans and Drawings
92-017 Dallas City Council Portraits Collection
02-004 Public Works and Transportation Department Photographs

Very special thanks goes to the following people and institutions for their help in the preparation of this book: Sally Rodriguez, Michael Aday, Willis W. Winters, Charles Stringer, Dallas Southern Memorial Association, Lee Park Conservancy, Kathy Smith, Carolyn Brown, and the Dallas Park and Recreation Department.

INTRODUCTION

The city of Dallas, the eighth-largest city in the United States, boasts a municipal park system that provides leisure, recreational, and cultural activities for the citizens of Dallas and the general public. It maintains more than 23,000 park acres, including over 400 individual parks. Those parks include recreational facilities such as community centers, swimming pools, athletic fields, and a metropolitan zoo. The city's first two parks, City Park (purchased in 1876) and Fair Park (purchased in 1904), predate the organization of the Park and Recreation Department. In response to management issues and concerns, an administrative park board was created by a city charter amendment in early 1905, and the first board members were appointed by Mayor Bryan T. Barry on May 23, 1905.

Dallas Parks have played a major role in the lives of Dallas citizens and, for that matter, anyone visiting Dallas. Long before radio, television, and video games, children and adults looked to parks for recreation, health, and even edification. This book tells the story of the early history of City of Dallas parks and park facilities, using selected parks with both local and national historical and social significance. Examples of parks with interest far beyond Dallas include Dealey Plaza (site of the assassination of John F. Kennedy), Fair Park (site of the 1936 Texas Centennial—essentially a world's fair), and parks built or augmented by New Deal agencies in the 1930s (featuring Works Progress Administration and Civilian Conservation Corps architecture). Some parks have important social significance, such as Trinity Play Park with its pioneering after-school program in the 1910s that cared for children whose parents worked nearby in the cotton mills. Many of the parks served as distribution sites for free milk for children, an early childhood health program put on privately by women's groups in the city.

Some parks have varied and fascinating histories, such as Fair Park, home of the annual State Fair of Texas and the site of the 1936 Centennial Exposition. The centennial was opened by Pres. Franklin Roosevelt and attracted over six million visitors at a cost of around $25 million. The state fair itself—the largest state fair in North America—is no slouch as an attraction. Fair Park's buildings, mostly dating from the Centennial, make up the largest campus of art deco architecture in America.

White Rock Lake is the in-town lake that started as a reservoir but has become an oasis of rest, athletics, and recreation. Other stories include the tale of the city's largest donation of land from Dr. W. W. Samuell, who bequeathed land and funds that today would be valued in the hundreds of millions of dollars. Over a dozen parks have been created from this single donation.

If there is any richness to this small volume, it is because of the quality of the holdings of the Dallas Municipal Archives. Established in 1985, the Municipal Archives is a part of the city secretary's office of the City of Dallas and is a repository for the historic and permanently valuable records of city government. Its goal is to document and preserve the actions of the city of Dallas and to effectively provide public access to information. The archives serve to help citizens and city employees research the story of the city, such as the history of a neighborhood, a historic election, or events in the city's past in a variety of ways. The photographs and documents reproduced in this book are just a sample of the treasures that await all researchers.

One

DALLAS'S FIRST PARKS

City Park, sometimes called Old City Park, is Dallas's first municipal park. It began in 1876 when J. J. Eakins offered 10 acres of land to the City of Dallas, partly purchased on behalf of the city by W. J. Keller. Presently the park occupies 13 acres. The property included the city's first water supply, and for many years it was a focal point of recreation and entertainment. It was also the first site of the Dallas Zoo, which was started in 1888 with the purchase of two deer and two mountain lions. The zoo was later moved to Marsalis Park, where it exists today. For a few years in the 1930s, the park was briefly renamed Sullivan Park in honor of Dan Sullivan, a former water superintendent. During the late 1930s, it was the site of labor demonstrations.

In later years, City Park embarked on a renewed life as home to Dallas Heritage Village, which is a living history museum that teaches the history of Dallas and North Central Texas through its collections of historic buildings and furnishings, representing the period from 1840 to 1910.

Fair Park is well known for the State Fair of Texas, the nation's largest state fair, but it is also a City of Dallas park open year-round. The 277-acre complex is registered as a National Historic Landmark and is home to museums, six performance facilities, a lagoon, and the largest Ferris wheel in North America. Many of the buildings in the complex were constructed for the Texas Centennial Exposition in 1936, which drew over six million visitors. Most of the buildings constructed for the centennial still survive, and Fair Park is recognized as the world's largest collection of 1930s art deco exposition buildings.

Although the state fair has been on the same site since 1886, since 1904 the fairgrounds have been owned by the city, which maintains them as a public park except during the annual three-week fair. Fair Park is also home to the Cotton Bowl stadium, site of many sporting events.

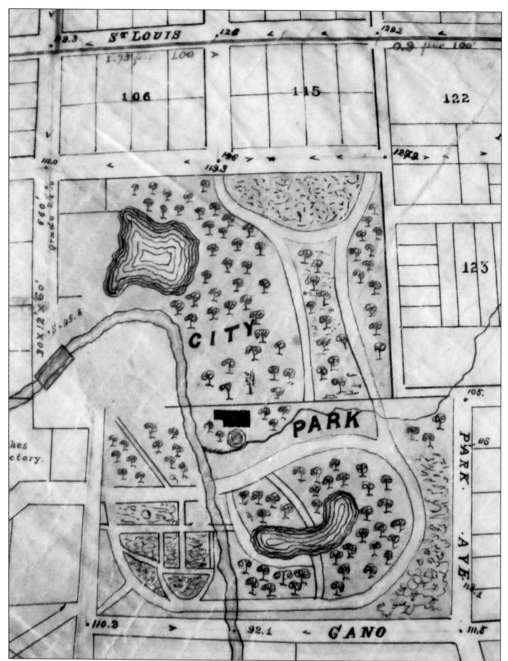

In 1876, City Park was on the edge of Dallas. Around it grew the city's first upscale neighborhood, called the Cedars. The park was the city's first expression of the City Beautiful Movement, a by-product of the teachings of Frederick Law Olmsted, architect of Central Park in New York. City Beautiful Movement advocates believed that beautification could promote a harmonious social order that would improve the quality of life and remedy social ills. With the opening of City Park, Dallas had progressed many miles since its founding 35 years earlier. This detail from a map of Dallas by Frank Dormant shows City Park as it appeared about 1888. Mill Creek is visible, as is the outline of the waterworks at Browder Springs and two ponds. (06-004.)

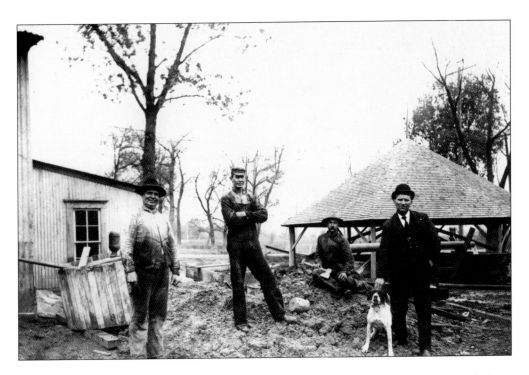

American Indian tribes were attracted to this park site by a series of natural springs, known later as Browder Springs after Edward C. Browder acquired the property in 1845. The springs figured in legislation that made Dallas the intersection of the Texas and Pacific and the Houston and Texas Central Railroads in 1871 and launched the town's rapid growth. The waterworks, above, were purchased from the Dallas Water Supply Company in 1881 and once provided over 250,000 gallons of water per day. The water from the springs was piped to Dallas's early residences by means of wooden mains, such as the one seen below. (91-060.)

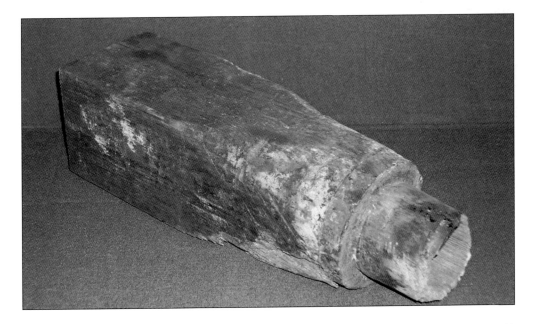

This is City Park as it appeared in 1911 in George Kessler's *A City Plan for Dallas*. It was landscaped with a naturalistic park design, which included promenades and a bandstand for outdoor concerts. (91-004.)

Pictured here is City Park in 1915. The statue seen is the Confederate Memorial, which was relocated to Pioneer Park in downtown Dallas in 1961. (95-025.)

The Confederate Memorial, relocated to Pioneer Park in 1961, is thought to be the city's oldest sculpture. Its dedication at City Park in 1896 was an all-day event that was attended by over 400 Confederate and Union veterans. (99-003.)

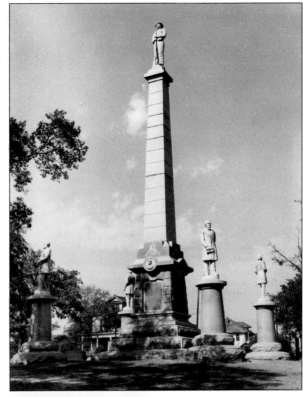

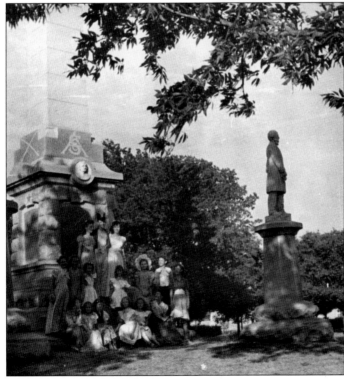

This *c.* 1940 image features a school outing to City Park. (03-002.)

When the Dallas County Heritage Society formed in 1966 to save the last antebellum mansion in the area, Millermore became the centerpiece of Dallas Heritage Village. The structure was built east of Dallas and was the home of William Brown Miller (1807–1899). (95-027.)

Today Dallas Heritage Village is a living history museum that includes a bank, general store, barn and livery, residences, and other historical buildings. (03-002.)

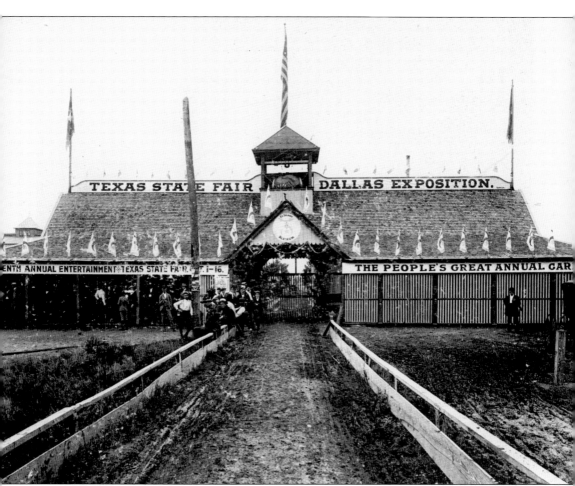

The state fairgrounds were established by the State Fair Association in 1886 on 80 acres outside the city limits. The land was derided by some members as "the worst kind of hog wallow" and was thus rapidly improved. This is the entrance to the fair in 1898. (96-003.)

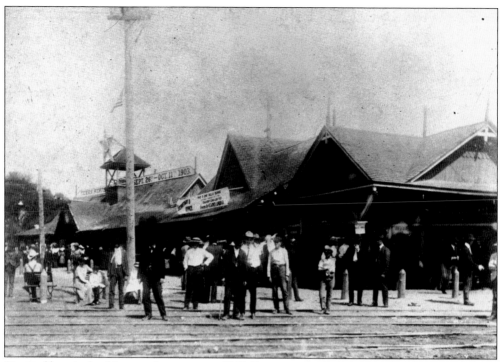

Pictured here is the fairground entrance in 1903. Economic misfortune at this time paved the way for the sale of the fairgrounds to the City of Dallas the following year. (96-003.)

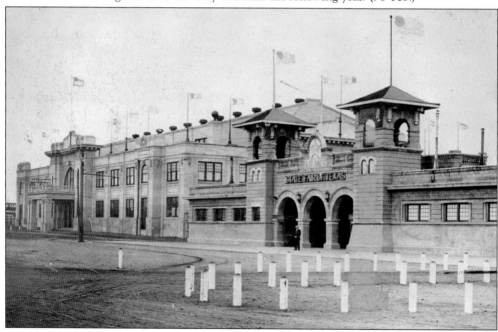

Following the sale of Fair Park, the city hired landscape architect and early city planner George Kessler to reinvent the fairgrounds. By the time this photograph was made of the Parry Avenue entrance in 1908, the park manifested some of the architectural styles seen at the 1904 St. Louis World's Fair, another Kessler project. (96-003.)

Dallas's first Coliseum (at left) was constructed by the city in 1910. In 1935, the Coliseum was renovated into the Centennial Exposition's administration building and now sports an art deco façade on its south face. The building now houses the "Women's Museum: An Institute for the Future." On the right is the Textile and Fine Arts Building, constructed in 1908, which had a crystal-paned dome and housed the Free Public Art Gallery of Dallas, the forerunner of the Dallas Museum of Art. The building was razed in 1958. (96-003.)

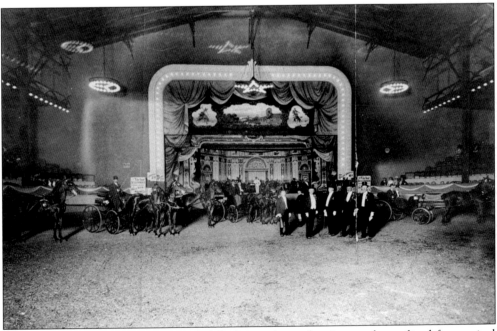

The Coliseum was primarily intended for horse shows, but it was also utilized for musical entertainment throughout the year and occasionally hosted political rallies. (96-003.)

This c. 1915 view of the main plaza shows the State Fair Exposition Building at left, constructed in 1905. It was incorporated into the 1936 renovation and additions and was known more recently as the Centennial or Transportation Building. The Alamo replica at the right was a fixture on the grounds from 1909 to 1936 before it was rebuilt at Second and Pennsylvania Avenues and then demolished in 1951. (96-003.)

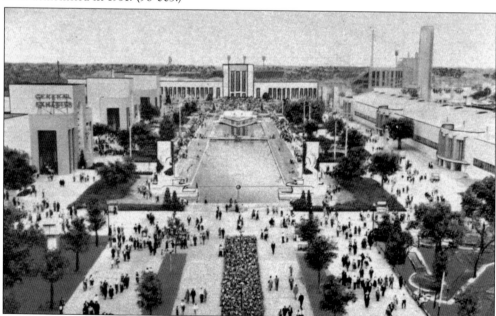

In 1936, Texas celebrated the 100th anniversary of the Texas Republic with a world's fair in Dallas. In just over 14 months, a skilled multicultural and multinational team of architects, planners, and artisans and an army of 8,000 laborers transformed the fairgrounds into a monumental showcase for Texas and the rest of the world. Pres. Franklin Roosevelt formally opened the centennial and spoke to a crowd of 50,000. (03-002.)

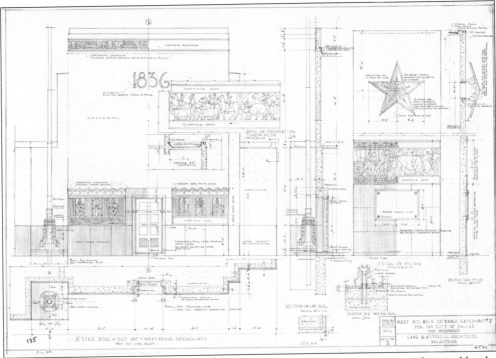

This drawing of the main entrance to Fair Park is the largest of four entry gates designed by the Dallas firm of Lang and Witchell in 1936. It features an 85-foot-high pylon, whose base displays a sculptural frieze by Texas artist James Buchanan "Buck" Winn. The plaza surrounding the pylon has been altered, although the secondary Grand Avenue and Martin Luther King, Jr. Boulevard entrance gates are still intact. (02-011.)

The Greater Texas and Pan American Exposition was held in 1937 to continue the excitement surrounding the centennial. The new fair involved a makeover of the art deco buildings into a semitropical, Latin American–themed park. Mayan, Aztec, and Incan design motifs were incorporated into the existing buildings. (95-027.)

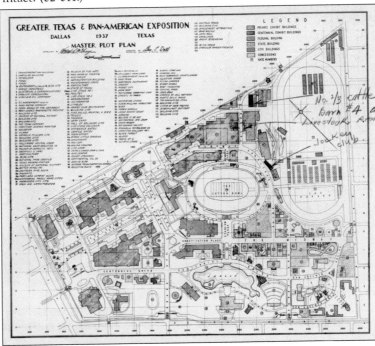

19

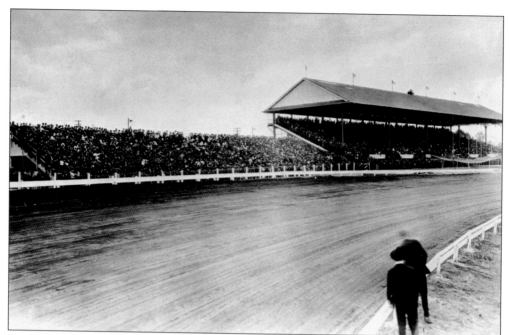

Sporting events have occurred at Fair Park throughout its entire history. Beginning with horse racing in the 1880s, and continuing over a century later with professional sports like football and soccer, sports have always been a major attraction at the park. This image of the horse track was made about 1907 during one of the periods when gambling was legal in Texas. (96-003.)

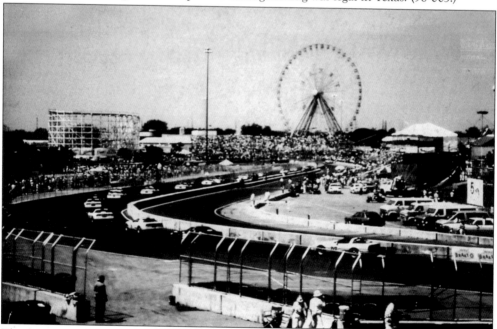

The first automobile race in the United States to go the distance of 100 miles occurred at Fair Park in 1905. It once again made racing headlines in 1984 when it hosted the U.S. Grand Prix that extended 261 miles over 67 laps. Keke Rosberg of Finland won the race in his Williams FW09 in spite of a newly laid asphalt surface that nearly melted under the Texas July sun. (96-003.)

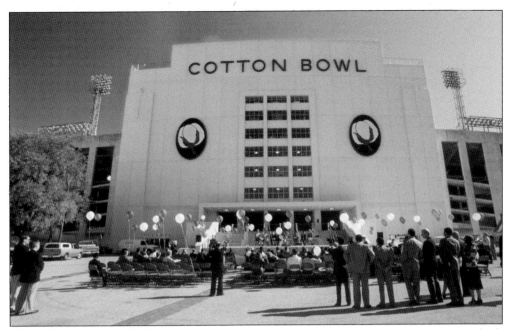

When contact sports like football became a dominant American pastime, stadiums were built in the park to accommodate the large crowds. A wooden stadium was built in 1921, but over 10 years it dwindled in comparison to bigger stadiums, prompting the City of Dallas to build the venerable Cotton Bowl in 1930. For nearly 75 years, the annual AT&T Cotton Bowl Classic has continued to draw crowds, now upwards of 68,000. The Cotton Bowl's rise to national prominence was further boosted when Clint Murchison, owner of the Dallas Cowboys, brought nationally televised games to Dallas from 1960 to 1969. (03-002.)

All eyes were on Fair Park's Cotton Bowl in 1994, when Dallas became one of the host cities for the 1994 soccer World Cup. Six games, including one quarterfinal match, were played over three weeks, attracting over 350,000 spectators and worldwide television coverage. (03-002.)

Two

EARLY DALLAS PARKS

A quarter century passed between the acquisition of the first City of Dallas park in 1876 and its second park, Fair Park, in 1904. Although the Committee on Parks and Public Grounds had existed since 1889, legal issues concerning the parks prompted the creation of the Dallas Park Board in 1905 to deal with the myriad contractual, management, and budgetary issues. The advent of a structured park administration opened the door to land donations and purchases.

At the same time, Dallas was one of many cities to embrace the new concept of urban planning and the City Beautiful Movement. A key plan in Dallas's early park system was to ensure every neighborhood in the city would be within short walking distance of a park. This included parks in disadvantaged areas, though facilities were usually of inferior construction.

As the city rapidly grew, the demand for parks came faster than the existing tax base would permit to buy them, and a bond issue of $500,000 was voted for parks, playgrounds, and boulevard purposes. Later bond issues funded the development of those early parks, which included shelters, comfort stations, playgrounds, and the forerunners of recreation centers, which were called community houses.

A number of non-city social programs used parks and park buildings for everything from free milk stations to toy distribution at Christmastime for underprivileged children. Free entertainment in Dallas parks was a major draw during fair weather months, including movie nights and music concerts. By the early 1920s, annual attendance at the entire park system reached half a million.

Many parks have changed names over the years, and quite a few have had land added or subtracted for various reasons. A few of these early parks, such as Trinity Play Park, no longer exist.

George Kessler (1862–1923), architect and early urban planner, was renowned as the principal designer of the St. Louis World's Fair of 1903. A rising star in the landscape architecture field, his larger interest in urban planning and beautification began with the reinvention of Fair Park in 1906, and in 1911 he unveiled a comprehensive master plan for Dallas's parks and boulevards. (95-023.)

Kessler's *A City Plan for Dallas* was prepared for the Dallas Park Board, though in truth it was a master plan that went far beyond parks. A levee system to control the flooding of the Trinity River, straightening crooked streets, and a union train station were among the improvements that ultimately came to fruition. Parks were implicitly part of this grand plan, intended to link all sections of the city. (91-004.)

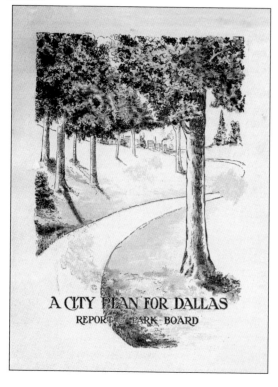

A CITY PLAN FOR DALLAS
REPORT OF PARK BOARD

Oak Lawn Park, now Robert E. Lee Park, was originally named for the adjoining neighborhood developed in the 1880s and 1890s. Already favored as a picnicking site, it was purchased by the city in 1909. The park kept its rustic design until it received a complete makeover in the 1930s. The photograph above shows Oak Lawn Park at the time of purchase. The photograph below is from about 1911. (03-002, 91-004.)

Oak Lawn Park, shown above around 1911, has changed a great deal in 100 years. The image below is of the fully landscaped Lee Park in 1954. (91-004, 03-002.)

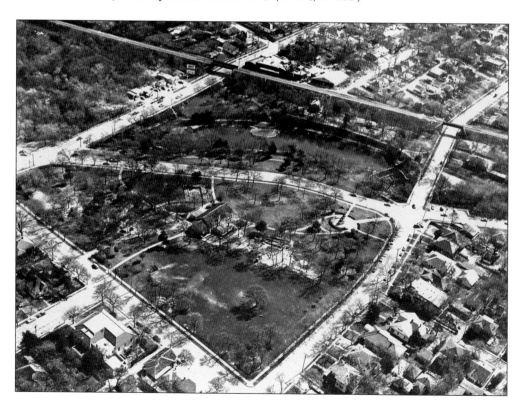

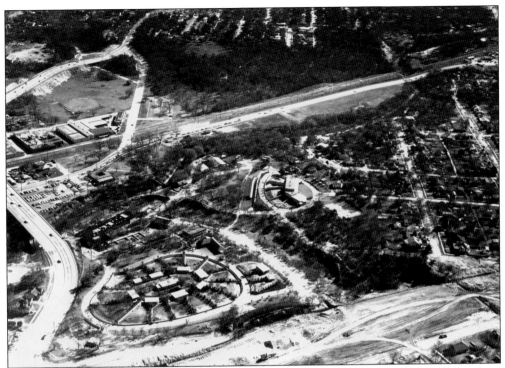

The Dallas Zoo is formally called Marsalis Park and was originally called Forest Park upon purchase in 1909. The zoo was founded in 1888, making it the first zoological park in the Southwest, though it moved first from City Park to Fair Park and then to Marsalis in 1910. Located in Oak Cliff, the park originally encompassed 50 acres but was later expanded to 95 acres. U.S. Interstate 35 is under construction in this photograph from the early 1960s. (03-002.)

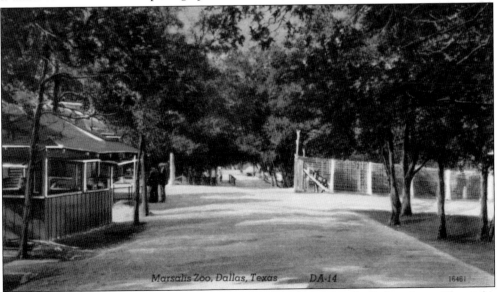

Marsalis Zoo, Dallas, Texas DA-14 16461

This postcard from the 1920s shows a still very rustic-looking Marsalis Park and zoo. The park's location among limestone cliffs and dense groves of native plants gives it a natural scenic beauty. (03-002.)

27

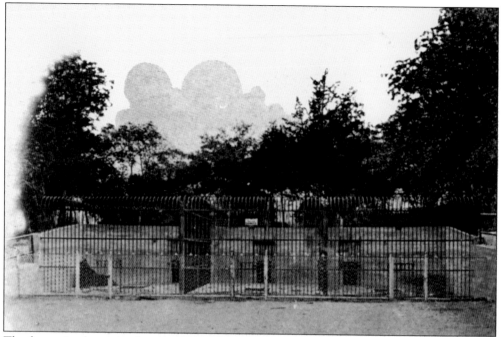

The first animal pens in the zoo displayed deer and mountain lions, but more exotic specimens were acquired after the move to Marsalis. In 1920, Frank "Bring 'Em Back Alive" Buck contracted with the park department to provide the city with a more extensive animal collection. Today the zoo has thousands of animals and is widely recognized for its children's zoo, "Wilds of Africa" exhibit, and award-winning Jake L. Hamon Gorilla Conservation Research Center. (95-025.)

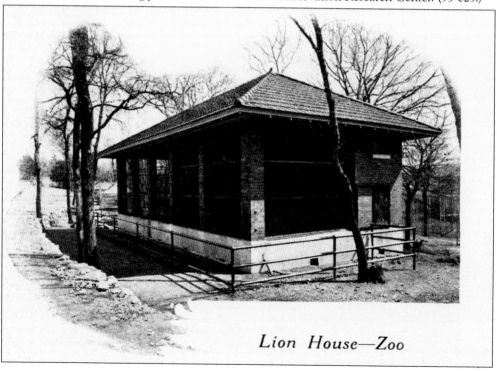

Lion House—Zoo

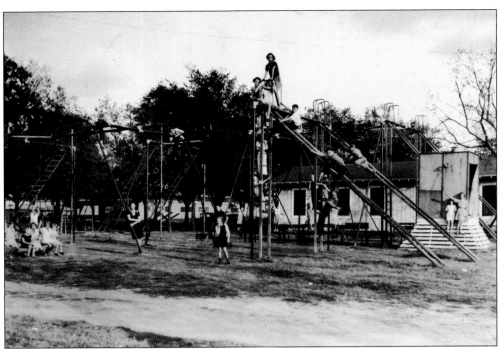

Trinity Play Park was originally 4.5 acres purchased in 1909 and dedicated Thanksgiving Day that year. It was located in what was then known as the Cotton Mills District and catered to the children of mill workers. A multipurpose building erected in 1915, it was the city's first prototype recreation center and at one time featured a milk station established by the local Infants Welfare Association. The park was renamed Fretz Park. The children above are enjoying the playground at Trinity Play Park around 1940; the children below are running a race about 1930. (03-002.)

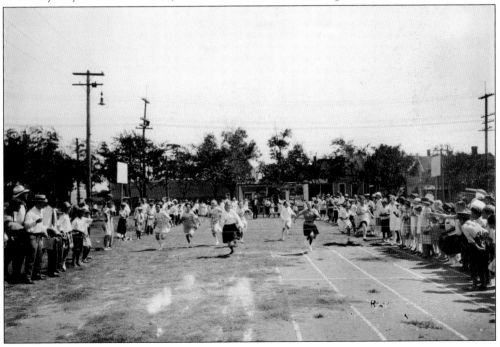

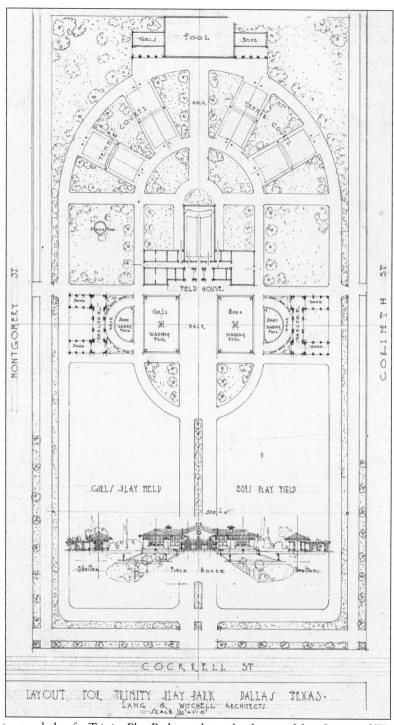

This architectural plan for Trinity Play Park was drawn by the noted firm Lang and Witchell, who designed many Dallas buildings. The field house and wading pool were built in 1915, and more improvements were added over the years. After the cotton mills neighborhood disappeared, the park became irrelevant and the field house was razed in the 1980s. (02-011.)

Turtle Creek Park, now William B. Dean Park, was originally named for the creek that winds through the Oak Lawn section of Dallas. It was acquired starting in 1913, through a series of purchases and donations, and is one part of a chain of parks fronting the creek. In gratitude for his leadership, the park was renamed for Dean, chairman of the park board from 1971 to 1975. The park is now an important element of the Katy Trail bike and pedestrian pathway linking multiple parks. The above image shows undeveloped Turtle Creek Park around 1915, and the image below depicts the creek as it appears today. (95-025, 03-002.)

In 1955, the Frank Lloyd Wright–designed Kalita Humphreys Theater was built on the east bank of Turtle Creek overlooking Dean Park. It is one of only three existing theaters designed by Wright, and its design is considered bold and innovative, growing out of Wright's organic theory of architecture. (03-002.)

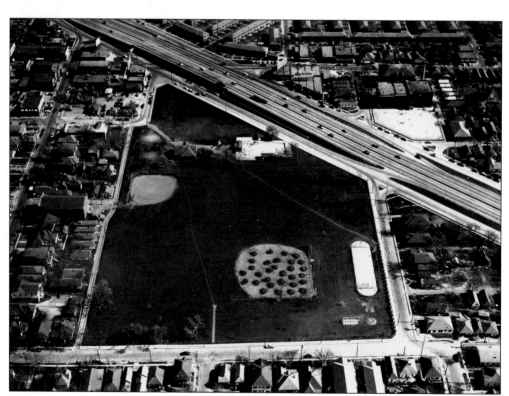

Originally known as Hall Street Negro Park, Griggs Park was acquired in 1915 and renamed in the late 1930s for Dr. Allen Griggs, a prominent African American Baptist minister and father of minister and novelist Sutton Griggs. Griggs Park was one of three parks built for African American citizens in the 1910s and 1920s. Located in old North Dallas, the park featured a field house, swimming pool, and baseball diamond in its heyday. (03-002.)

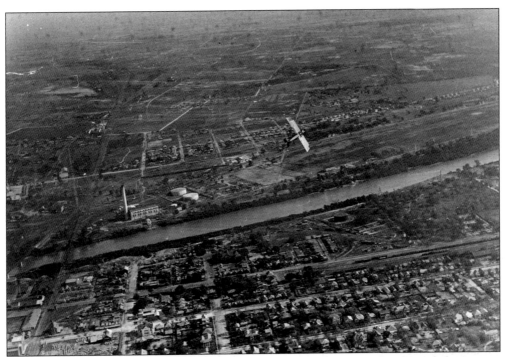

Originally Dallas's first reservoir, Bachman Lake's shoreline was transferred to the park department in 1930 for development as a park. The lake was created in 1903 by damming the Bachman branch of the Trinity River. This aerial view was made around 1918 by a Love Field pilot. A biplane is performing a stunt in the foreground, and the Bachman water treatment plant is visible. (01-003.)

Acquired in 1908, Central Square was the fourth park established by the park board. Bounded by Swiss Avenue and Oak and Floyd Streets, this charming town square–style small park hosted popular music concerts in the years before World War I. It is now part of the historic Wilson block of restored vintage homes. (03-002.)

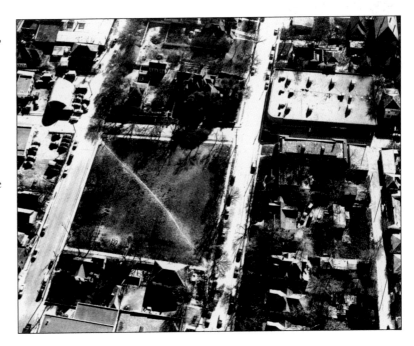

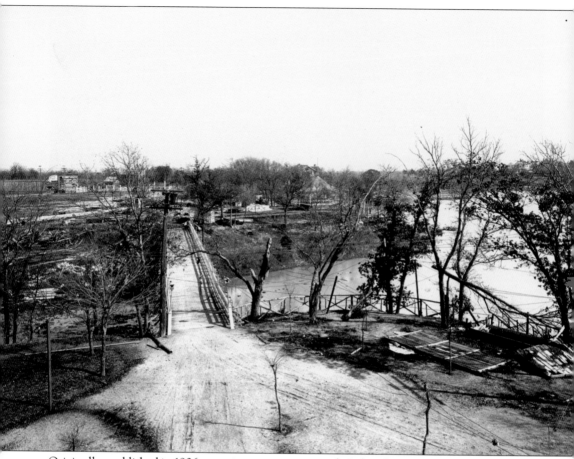

Originally established in 1906 as a private amusement park, Lake Cliff Park once boasted a massive swimming pool, amusement rides, and three theaters, one of which provided Dallas with its first summer musical series. With its purchase by the city, Lake Cliff Park became the site of the city's first municipal swimming pool. This photograph shows Lake Cliff at the time of purchase in 1914 after previous owner C. A. Mangold demolished most of his buildings. (03-002.)

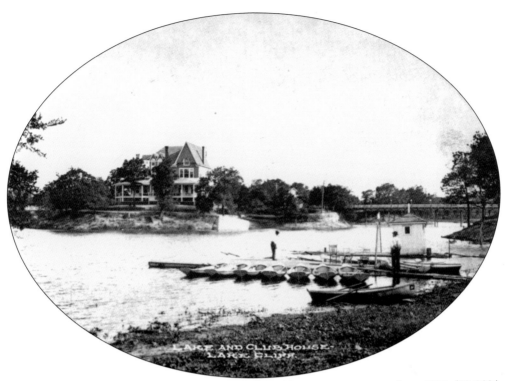

This view of Lake Cliff Park shows the Cliff Café and boating concession about 1913. (03-002.)

In 1919, planner George Kessler created a master plan for Lake Cliff that included a baseball diamond and football field, adult and children's swimming pools, a boathouse, and a formal garden. (02-011.)

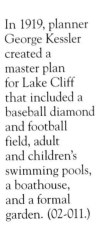

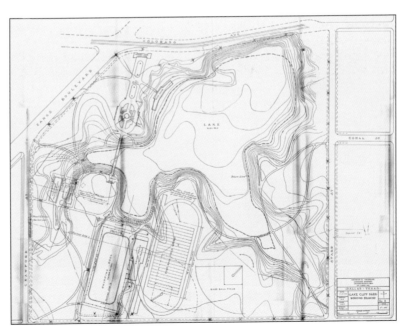

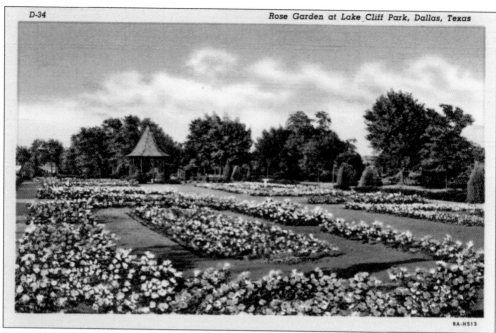

8A-H513

It is unclear how much of Kessler's formal garden was developed, but a beautiful rose garden was designed by landscape architect Wynne Woodruff in 1934. The initial 2,000 rosebushes were provided by the Oak Cliff Society of Fine Arts. (03-015.)

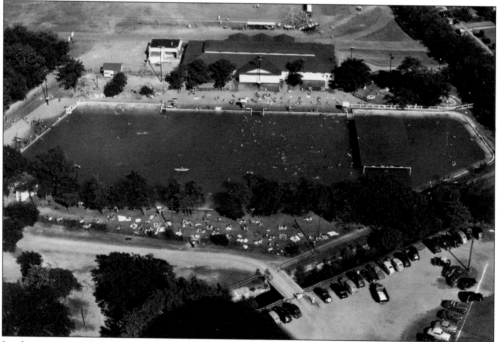

In the summer of 1947, Lake Cliff's pool would have been one of the coolest spots in Dallas. A favorite spot for Dallasites for decades, the bathhouse was designed by the firm of Fooshee and Cheek and opened in 1921. The swimming pool was closed in 1959 and the bathhouse dismantled soon after. (03-002.)

Library or Turner Plaza—Undeveloped

One of Dallas's smallest parks is located at Jefferson Boulevard and Marsalis Avenue in Oak Cliff. Land for Turner Plaza was donated in 1913 by Edella K. Turner, who was devoted to bringing culture and refinement to Oak Cliff. The tiny triangle is home to the Dallas Public Library's first branch, an Andrew Carnegie donation, in 1914. The 1914 building was replaced in 1966. In 1935 the park board lengthened the name of the plaza to Mrs. E. P. Turner Plaza to enshrine the memory of the woman who had been instrumental in bringing the library to Oak Cliff. (03-002.)

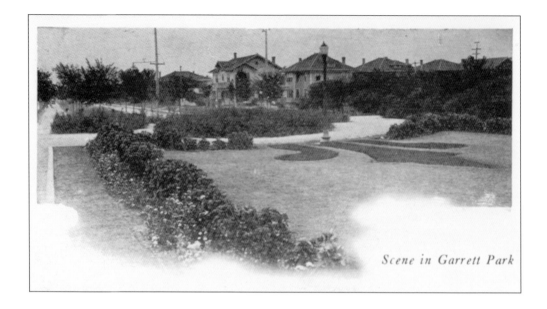

Scene in Garrett Park

Located at Bryan Street and Garrett Avenue, Garrett Park was established in 1914. The property was purchased from Alexander C. Garrett, the Protestant Episcopal bishop of North Texas, and was named in his honor. The park once adjoined St. Mary's College, a women's college founded by Bishop Garrett. Located in one of the most highly developed residential districts of the city, Garrett Park provided access to a wading pool, a playground, and free outdoor programs during the summer. (95-025, 03-002.)

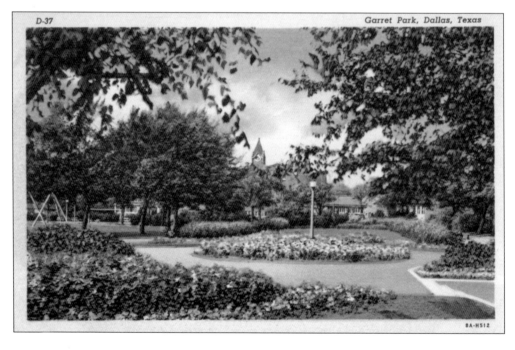

D-37 Garret Park, Dallas, Texas

8A-H512

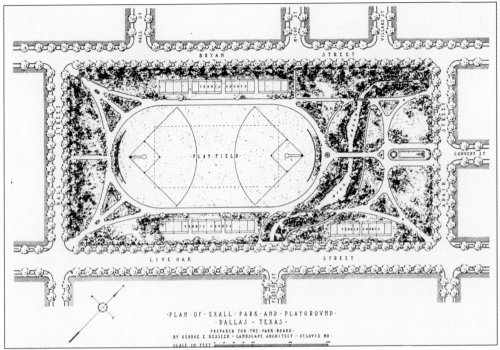

Established in 1914, Exall Park is located at the corner of Hall and Bryan Streets. The park was named for the founder of the Texas Industrial Congress, Henry Exall. It was located directly across from St. Paul's Sanitarium, the oldest private hospital in the city. The park once boasted a wading pool, two lily ponds, and during the summer months hosted free motion picture screenings four times a week. George Kessler's original plan from 1915 is pictured above, and the lily ponds are shown below. (95-025.)

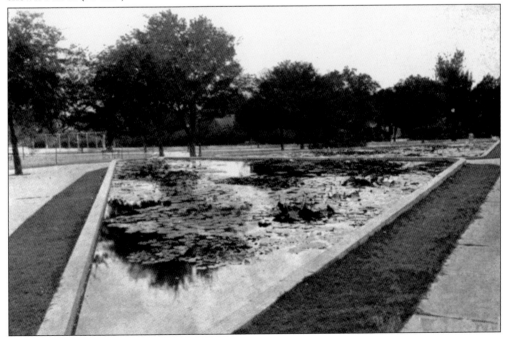

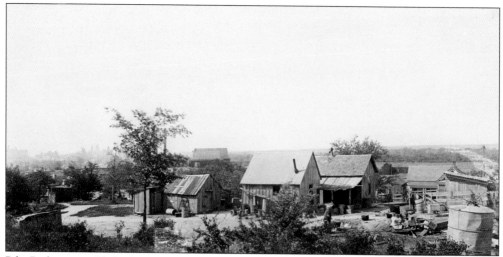

Pike Park was established in 1914 as Summit Play Park in the working-class neighborhood of Little Mexico. This image shows the land prior to development. Situated on a hill, the park commanded a dramatic view of downtown Dallas. (95-025.)

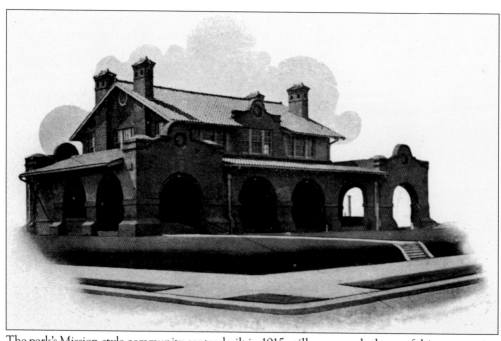

The park's Mission-style community center, built in 1915, still serves as the heart of this community. It has played host to countless festivities and commemorations over the years, including the annual Cinco de Mayo observance. Park amenities originally included a wading pool, field house, and public showers. (96-003.)

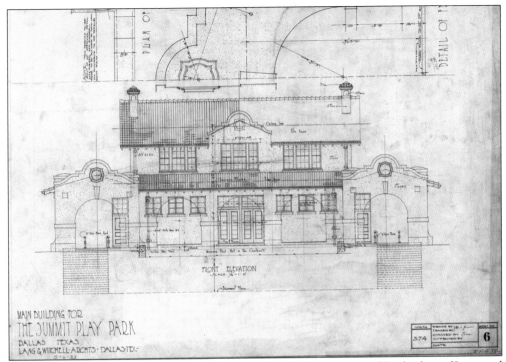

This page from the hand-drawn plans for Summit Play Park was executed by the firm of Lang and Witchell, who designed many other buildings in Dallas and the Southwest. (02-011.)

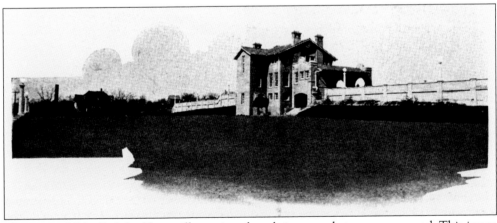

The original Pike Park building still remains, though its second story was removed. This image from 1921 shows the backside of the building, which faces towards the Trinity River. (95-025.)

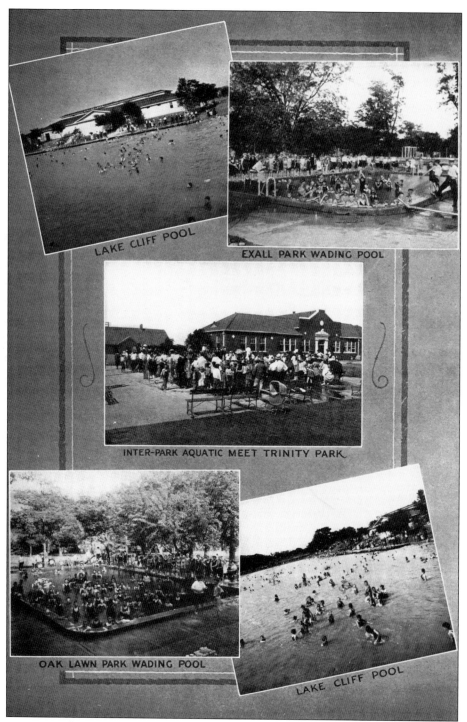

Swimming pools are a necessary component of parks in Texas. In the days long before air conditioning, Dallas public swimming and wading pools provided relief and recreation for the masses. This page from a 1923 park department annual report shows off its impressive aquatic offerings. (95-025.)

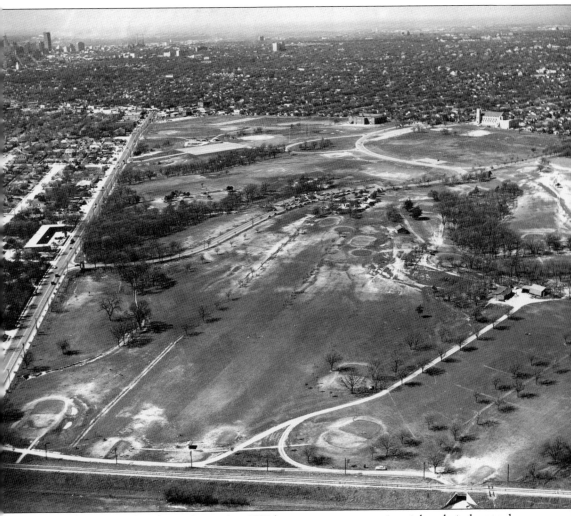

Tenison Memorial Park was donated in 1923 by two parents as a memorial to their deceased son. E. O. and Annie M. Tenison provided a stretch of rolling hills off East Grand Avenue, which grew to include 225 acres of land. The Tenisons donated the land at a time when golf was growing in popularity in Dallas. As a result, the park department developed what would become Dallas's first city-owned public golf course in 1924. The course was a favored stop for the infamous gambler Titanic Thompson and a training ground for future golfing legend Lee Trevino. (03-002.)

Elizabeth Patterson Kiest Memorial Park in Oak Cliff, better known as Kiest Park, was acquired by the city in 1930. It was donated by Edwin J. Kiest, publisher of the *Dallas Times-Herald*, in memory of his wife and was officially dedicated in 1932. (03-002.)

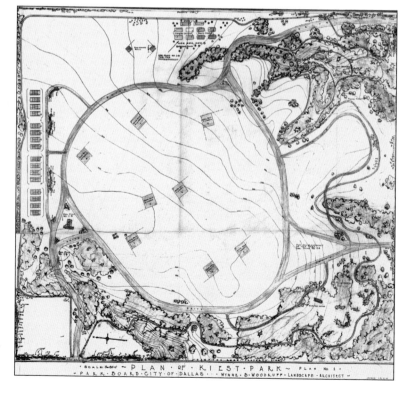

Kiest Park benefited from a master plan developed by Wynne Woodruff, who was hired by the park board in 1934 to create plans for the entire park system. This is Woodruff's hand-drawn plan, which features a circular outer drive, multiple baseball diamonds, and a bridle path. (03-015.)

Purchased in 1924 with bond money, the formerly private Wahoo Club and lake adjoined Julia P. Frazier School. In the 19th century, the area was known as Buzzard Springs. In the 1930s, it received a playground and community house, and a new recreation center was built in 1964. The site included a 12-acre fishing lake, now drained, and was renamed for civil rights activist Juanita Craft. This view is from the 1950s. (03-002.)

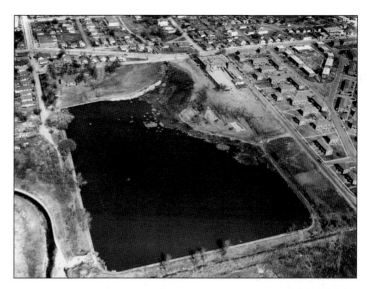

Acquired in 1924, Lagow Park was another of the school-connected parks purchased by the city. Situated across the street from Lagow School, park improvements included the installation of a junior pool as well as playground equipment. The park was originally part of the Lagow family land holdings and was renamed for Mildred Dunn, a 30-year park department employee who devoted her career to improving the park. (03-002.)

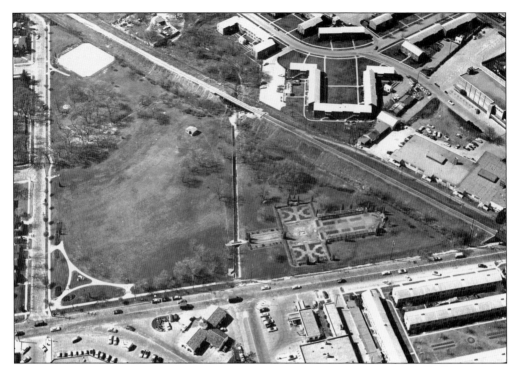

Craddock Park was originally 9 acres donated in 1922 by Lemuel and Belle C. Craddock, who were pioneer citizens of Dallas. Its major feature for many years was its formal rose garden, planted in 1934 with 1,800 rosebushes. A portion of the park was lost when the Dallas North Tollway was built in 1968. Above is the park as it appeared prior to the tollway. Below is the 1934 plan for the formal rose garden. (03-002, 03-015.)

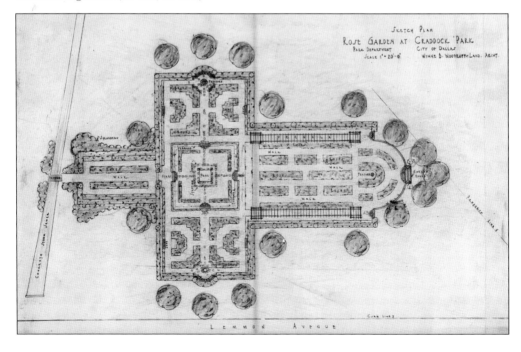

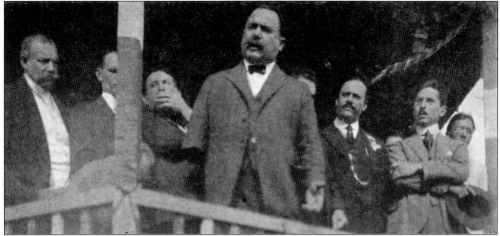

The political chaos of the Mexican Revolution (1910–1920) resulted in a surge of Mexican immigrants who settled in the Dallas area. In 1919, the park board leased property located on Caruth Street near Griffin. Unofficially called "Mexican Park," facilities included free showers and playground equipment. The park became the scene of community celebrations, including a visit from Pres. Álvaro Obregón of Mexico (center, in bow tie). This is one of the only images of Obregón's visit. (95-025.)

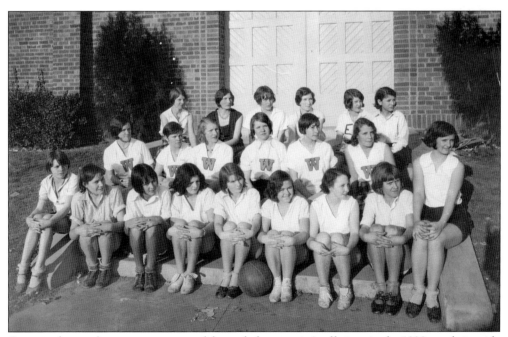

Organized sports became a core part of the park department's offerings in the 1920s, and citywide league competition channeled the restless energy of Dallas youth. This photograph shows the 1929 citywide girls' volleyball champs from Exall, Winnetka, and Trinity Play Parks. (03-002.)

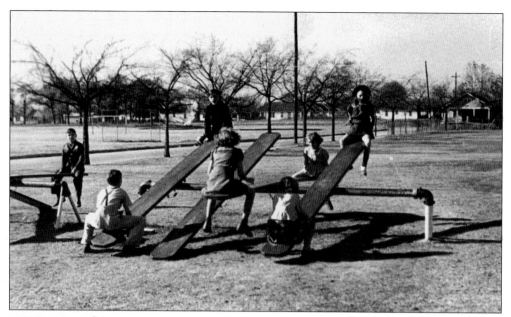

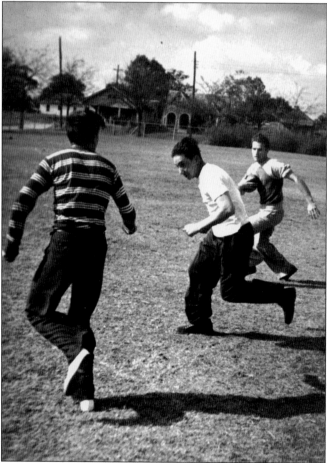

Located in South Dallas, Exline Park was the first park acquired by the park board working in cooperation with the Dallas Board of Education. A part of the Albert Samuel Exline estate, it received a community building in the late 1930s, which was later replaced by a larger recreation center. Above, children enjoy the seesaws at Exline. At left, a group of boys play touch football around 1940. (03-002.)

48

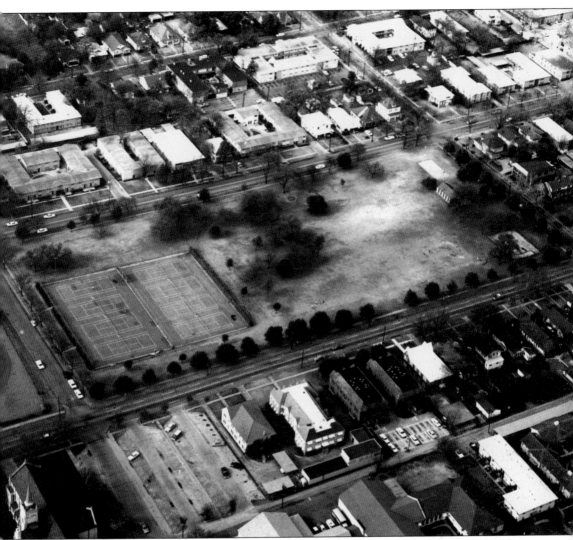

The city of Dallas has a long connection with the Cole name. Reverchon Park sits atop what is known as the "Cole Purchase." Cole Park was originally leased by the city in 1921 from the heirs of one of Dallas's earliest pioneers, Dr. John D. Cole. In 1923, the city exercised a clause in the lease contract that allowed the city to purchase the property. The family allowed the city to purchase the land at half its appraised value so that the park would remain as a memorial to John Cole's memory. (03-002.)

In 1930, the children of John and Helena Walford donated their parents' homestead to the park department. Intended as a memorial, the home was preserved as a community center that housed a toy library and game room. (03-002.)

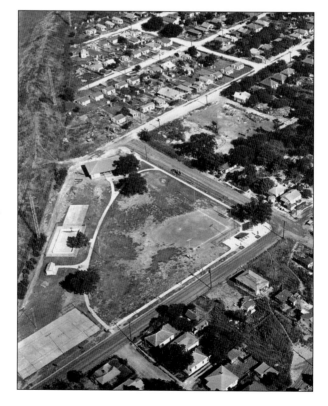

Established in 1915 as Oak Cliff Negro Park, Eloise Lundy Park was the first city park dedicated solely for use by African Americans. Located near the Trinity River on Sabine and Cliff Streets, the park was one of only a handful of properties set aside for use by the city's minority population before desegregation. The park was later renamed for Eloise Lundy, the beloved recreation center director of Oak Cliff. The Trinity River levee is to the left. (03-002.)

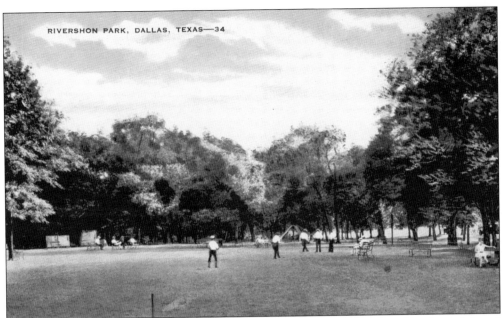

Reverchon Park, located at Welborn Street and Maple Avenue, was purchased by the park board in 1914. Originally called Turtle Creek Park, the property was renamed for noted botanist Julien Reverchon. The park's 39 acres were originally an area known as Woodchuck Hill. Famous for the tallest oak tree in Dallas and its Gill Well mineral springs, Reverchon Park soon gained a reputation among generations of youth for its baseball diamonds. Above is an early postcard of the park. Below is a much later group of baseball players at Reverchon around 1943. (03-002.)

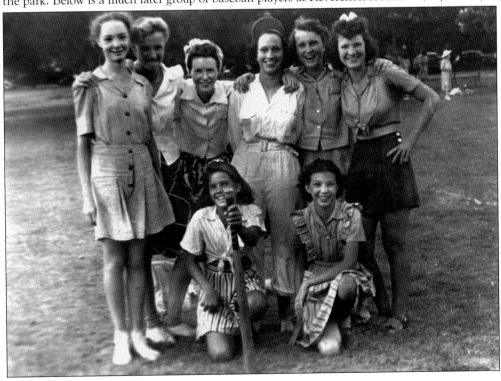

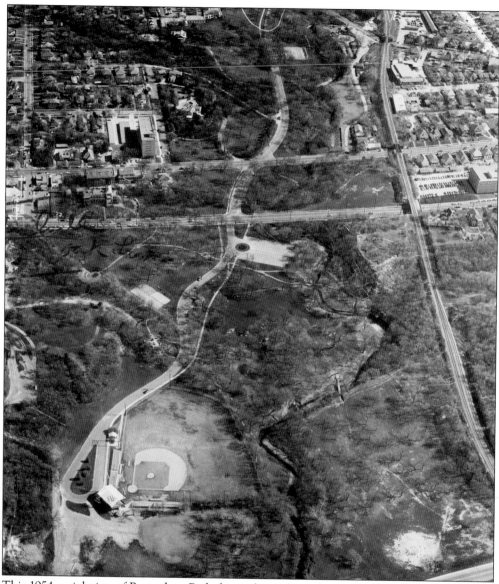

This 1954 aerial view of Reverchon Park shows the park's welcome green space in the midst of residential and business development. The baseball diamond was prominent then just as it is today. (03-002.)

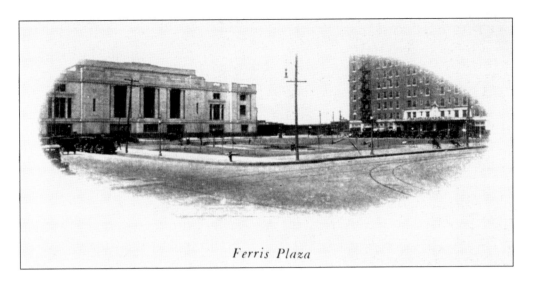

Ferris Plaza

Ferris Plaza is located directly across from Union Terminal Station on Houston Street in the central business district. This park was considered the railroad gateway to Dallas and was part of an original plan advanced by the *Dallas Morning News* and George Kessler to surround the station with green space to make it open and inviting. Ferris Plaza was the only park constructed during the building hiatus imposed on the city by World War I. Above is the plaza as it appeared when it had newly planted trees. Below shows the plaza in the late 1970s. Reunion Tower can be seen behind Union Station, and work is just starting on Reunion Arena on the left. (95-025, 03-002.)

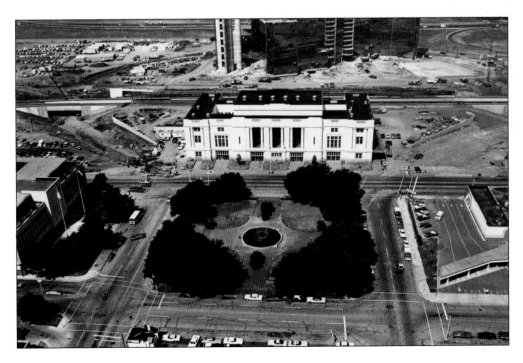

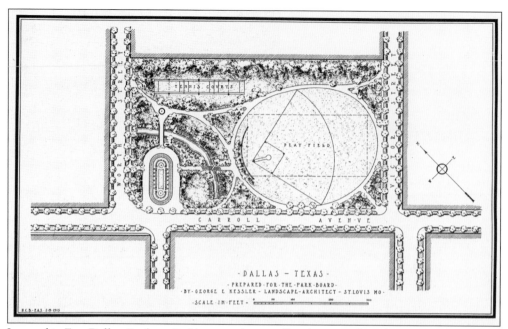

Located in East Dallas, Buckner Park's original tract of land was purchased out of the Dallas Park Board's bond issue in 1913. The park was named in honor of Dr. R. C. Buckner, founder of the Buckner Orphan's Home. This is George Kessler's original plan from 1915. (95-025.)

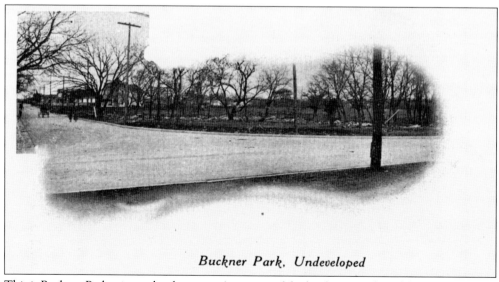

Buckner Park, Undeveloped

This is Buckner Park prior to development. A portion of the land was purchased from Dr. Buckner, while an additional tract of land was bequeathed to the park department by the estate of Dr. W. W. Samuell, a Dallas area physician and philanthropist. (95-025.)

Received in 1923 as a memorial donation from the children of Dr. John H. and Annie Stevens, the 40-acre Stevens Park, located in Oak Cliff, became one of two golf parks to open in Dallas in 1924. The pastoral setting in that part of Oak Cliff blended well with the design of the course, making the park an instant success. At right is the park and course as they appeared in 1954. Below is a 1925 advertisement demonstrating how realtors touted the park to potential home buyers. (03-002, 95-023.)

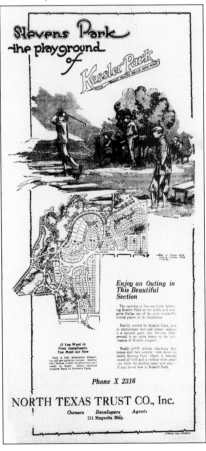

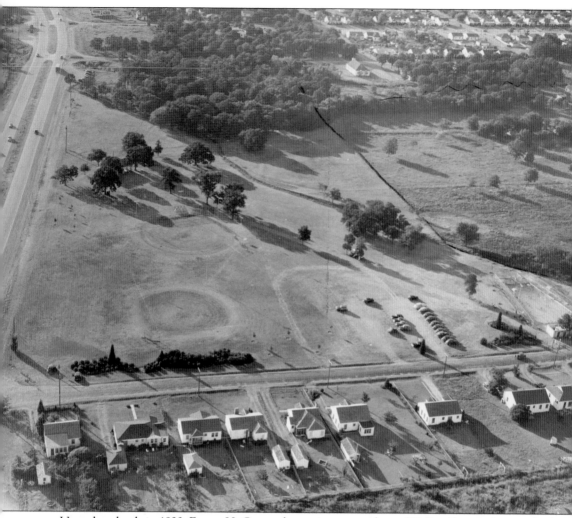

Upon her death in 1923, Emma H. Grauwyler, a pioneer resident of Dallas County, bequeathed her entire estate to the City of Dallas. Her will stipulated that her home and grounds become a city park dedicated to the memory of her husband, John. A fund that provides for fresh flowers for their resting place continues to this day. This aerial shows the park about 1947. The new Harry Hines Boulevard is on the left. (03-002.)

Three

NEW DEAL PARKS
IN DALLAS

Aimed at relief, recovery, and reform, the New Deal was Pres. Franklin Roosevelt's answer to the economic crisis triggered by the stock market crash of 1929. With millions of Americans unemployed as a result of the financial collapse, the federal government took measures to get the United States back on its feet. The Works Progress Administration (WPA) was the coordinating body for many of the government's "alphabet agencies." During this period, the City of Dallas executed a number of WPA projects, employing many of the more than 15,000 Dallasites who were on the local relief rolls. The City of Dallas's WPA park improvement projects totaled nearly $300,000 in federal funding, $124,000 of which was contributed by the city. Dallas led the state with 13,365 people on local WPA payrolls.

As part of a large and complex organization, the programs of the WPA were coordinated by federal, state, and local authorities. The Dallas office of the WPA, organized under Texas Department No. 4, administered programs under several different organizations. These programs included the PWA (Public Works Administration), which split funding between city and federal sources and built several buildings in Fair Park; the WPA (Works Progress Administration), which constructed parks and built roads; the NYA (National Youth Administration), which contributed to the construction of Dealey Plaza; and the CCC (Civilian Conservation Corps), which built parks and did other outdoor construction. The CCC was most famous in Dallas for its camp at White Rock Lake, which had educational and training opportunities for young men.

Many improvements funded through New Deal agencies were not on a grand scale. The addition of a swimming pool or sidewalks made a huge difference in a neighborhood park and as a whole in Dallas's quality of life. One thing is certain, Dallas parks would not be what they are today without the improvements they received during this time period.

WESTERN UNION

1220 (53) MO

CA294 115 GOVT 2 EXTRA=SN WASHINGTON DC 19 1031A

JAMES W ASTON=

CITY MANAGER DAL=

:PRESIDENT HAS DESIGNATED WPA PROJECT #40383 IN AMOUNT $292,070 TO IMPROVE CITY PARKS INCLUDING EXCAVATING LEVELING GRAVELING GRADING AND SODDING CONSTRUCTING COMFORT STATIONS TENNIS COURTS SOFTBALL AND BASEBALL DIAMONDS DRIVEWAYS SIDEWALKS CURBS GUTTERS PAVEMENT RETAINING WALLS AND SEATS IMPROVING SHELTER HOUSES FOUNTAIN AND SIDEWALKS REMOVING SILT FROM LAKES LAYING PIPE INSTALLING DRINKING FOUNTAINS SANITARY AND STORM SEWERS PLUMBING FIXTURES AND FITTINGS FLAG POLE LIGHTING FACILITIES PERISTYLES AND WATER MAINS REMOVING AND INSTALLING BRIDGES PICNIC UNITS AND PLAYGROUND SETS RECONSTRUCTING WADING POOLS SOFTBALL AND BASEBALL DIAMONDS TRIMMING AND PLANTING TREES LANDSCAPING GROUNDS AND PERFORMING INCIDENTAL AND APPURTENANT WORK STOP PROJECT NOW ELIGIBLE FOR OPERATION AT DISCRETION OF STATE WORK PROJECTS ADMINISTRATOR=

TOM CONNALLY BY SECRETARY.

This telegram from U.S. senator Tom Connally was forwarded from the city manager to park department director L. B. Houston. It was the City of Dallas's green light to embark on the most ambitious construction program in the history of Dallas parks. (95-023.)

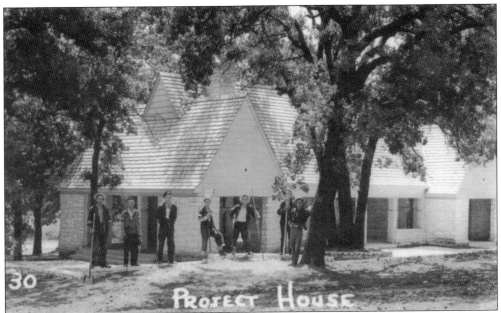

Bachman Lake held privately owned clubhouses and buildings up to the 1930s but later added public facilities. At the same time the CCC was developing and improving White Rock Lake, they were also working on Bachman. A shelter house and a comfort station were built in 1939. The shelter has been renovated, but the comfort station was razed in the 1980s. Above is one of Bachman's CCC buildings. Below is the entire lake and surrounding park in 1954. Love Field, the municipal airport, is to the right. (Courtesy Cathy Smith, 03-002.)

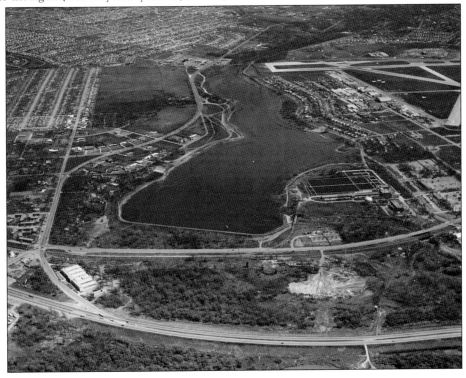

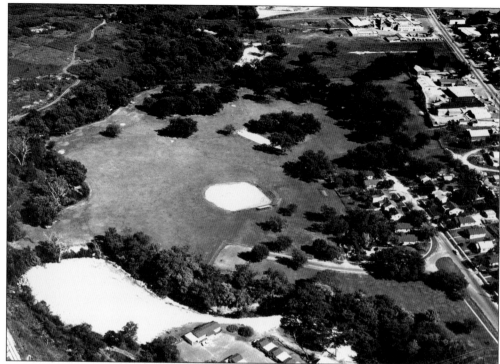

Originally part of the Cabell family farm, Eighth Street Negro Park in Oak Cliff was purchased in 1938 as a segregated park. It was dedicated on Juneteenth in 1940 with a ceremony honoring the few remaining former slaves in Dallas. In the mid-1940s, lights, a softball field, and a six-hole golf course with sand greens were added. The Dallas Negro Chamber of Commerce helped rename the facility Moore Park in honor of African American pioneer Will Moore. (03-002.)

Martin Weiss Park was a relatively new park in the 1930s and didn't receive attention until the WPA program, primarily because it was originally outside of the city limits. By 1938, it had landscaping, picnic units, a handsome stone bridge, and this charming stone entrance gate. (03-002.)

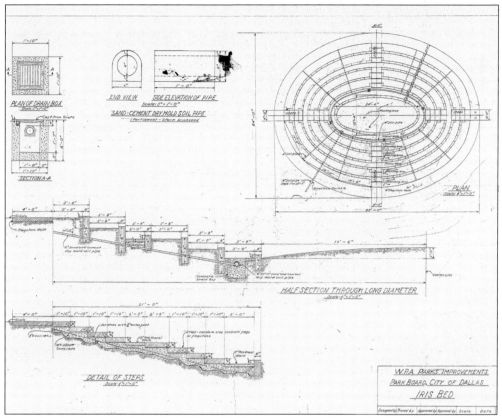

Reverchon Park received over $20,000 in WPA improvements. In 1938, a formal iris garden was constructed that was the centerpiece of the park's New Deal work. This drawing shows part of the "Iris Bowl." (91-011.)

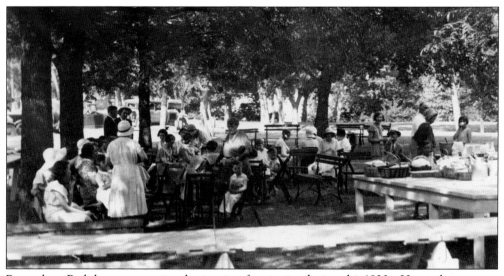

Reverchon Park became a major destination for picnics during the 1930s. Here a large group enjoys a gathering under a pecan grove about 1934. (03-002.)

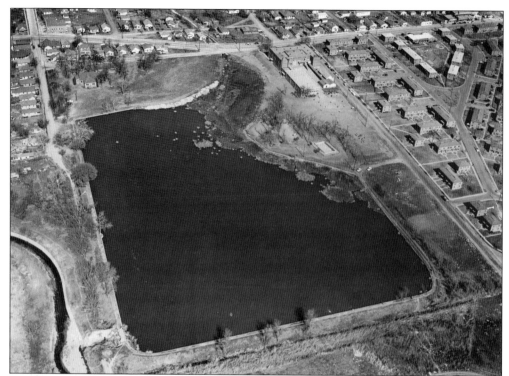

Wahoo Park (now Juanita J. Craft) received a number of improvements in the early 1930s, including a wading pool, comfort station, and two tennis courts. Under the WPA program in 1938, a community building was added, as well as landscaping, planting, and walks. The community building is in the upper left-hand corner by the trees. (03-002.)

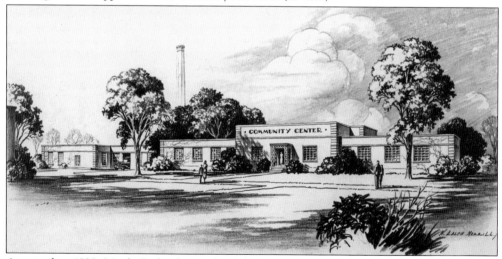

Acquired in 1938, Maple Park adjoins the federal government housing project Cedar Springs Place. The park was required by the agreement that brought the Public Works Administration housing project to Dallas. WPA work included a children's pool and playground equipment. The park is directly in front of this New Deal–era community center that was erected in 1941. Maple Park was renamed for Maria Luna, a neighborhood matriarch and owner of Luna's Tortilla Factory. (95-023.)

Dealey Plaza is famous for many things, both locally and nationally. The park rests on a bluff near the Trinity River, where a natural low-water crossing was identified in 1841 by Dallas's founder, John Neely Bryan. The ford was at the intersection of two major American Indian traces and was the site of Bryan's cabin. It was also the site of the first ferry and bridge over the Trinity, which played an important part in the development of the city. This 1933 aerial view shows the undeveloped area where Dealey Plaza was built. The Trinity River's levees are not finished, and the plaza was built just north of the Commerce Street Bridge and to the left of the buildings. (02-004.)

The area became even more important as a unique traffic solution—a triple underpass. The triangular design was an engineering success that restructured three primary streets to merge into one and created a major new gateway into Dallas from the west. (02-011.)

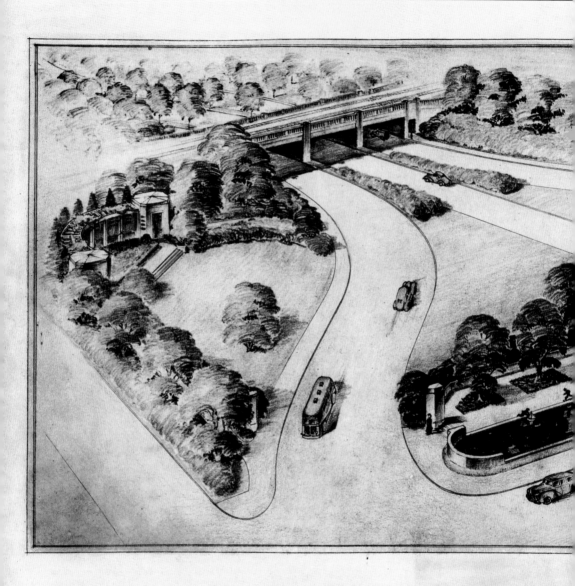

The elements of Dealey Plaza can be seen in this plan by architects Hare and Hare: concrete pergolas at the north and south ends of the park, each with a stairway; the arched colonnades that define the pergolas, flanked on the ends by shelters; twin reflecting pools with fountains on

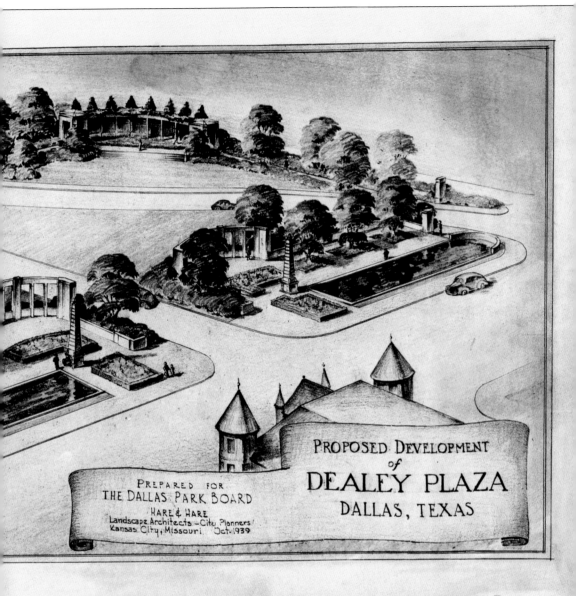

PREPARED FOR
THE DALLAS PARK BOARD
HARE & HARE
Landscape Architects – City Planners
Kansas City, Missouri Oct. 1939

PROPOSED DEVELOPMENT
of
DEALEY PLAZA
DALLAS, TEXAS

2D-1-D

the west boundary of the park, separated by Main Street; and the planter boxes and peristyles that complement the reflecting pools. (02-011.)

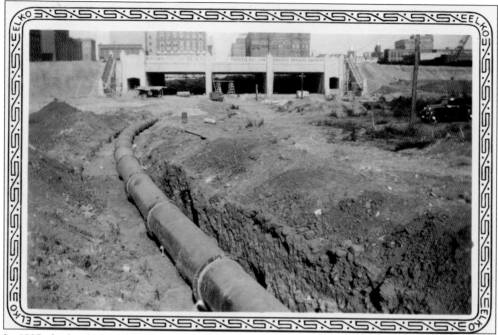

In 1935, the land around the plaza was transferred to the Dallas Park Board to be landscaped as a public park. Named for the *Dallas Morning News* publisher and civic leader George Bannerman Dealey, the park was a cooperative project between the city, the Texas Highway Department, and the WPA. This image shows the triple underpass under construction. The park is on the other side. (91-060.)

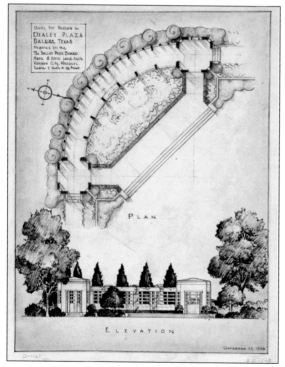

Further work on Dealey Plaza was completed by the National Youth Administration between 1937 and 1941. The Kansas City architecture firm Hare and Hare designed the landscaping and art deco–style colonnades. (02-011.)

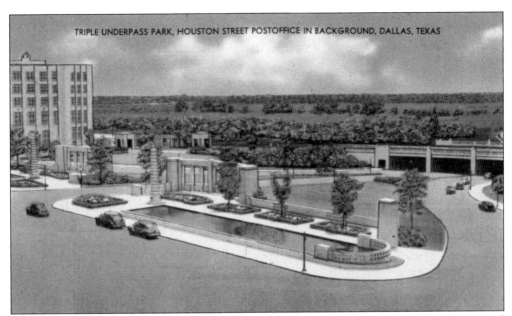

The park was finished in 1941 and is considered an architectural treasure. Dealey Plaza was named a National Historic Landmark District in 1993 by the National Park Service to preserve Dealey Plaza, street rights-of-way, and relevant buildings and structures by the plaza. (03-002.)

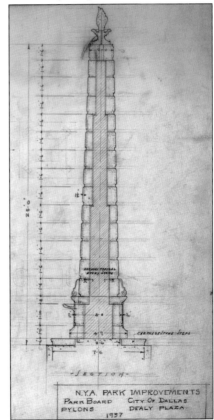

In 1949, the park board dedicated a statue of George B. Dealey in the park. The bronze statue, sculpted by Felix de Weldon, replaced one of these two pylons at the Main Street entrance to the park. (02-011.)

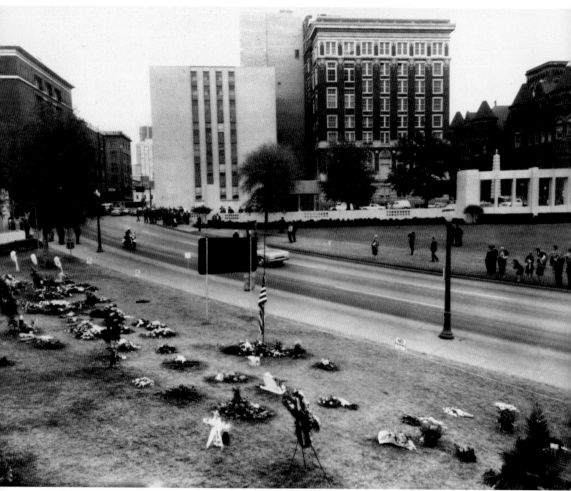

Sadly, Dealey Plaza is also known internationally as the site of the assassination of Pres. John Fitzgerald Kennedy on November 22, 1963. The 35th president of the United States was mortally wounded as his motorcade headed toward the underpass to the west on Elm Street. The assassin also critically wounded Texas governor John Connally. From this spot, the president was rushed to Parkland Hospital, where he died. This photograph was made the day of the assassination, as the park became a makeshift memorial to the slain president. (91-001.)

In 1928, the Dallas Southern Memorial Association began plans for the placement of a statue of Robert E. Lee in Oak Lawn Park. Executed by sculptor A. Phimister Proctor, the bronze statue was unveiled on June 12, 1936, by Pres. Franklin D. Roosevelt. (Dallas Southern Memorial Association.)

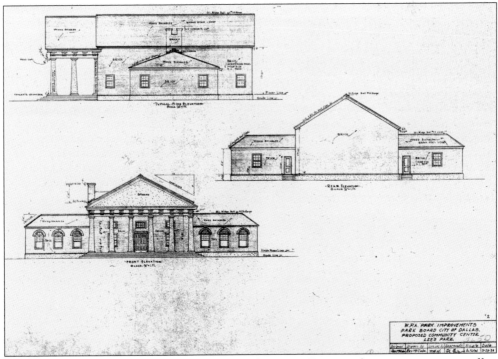

The park's name was changed to Robert E. Lee Park in 1936. Two years later, in a cooperative effort by the Southern Memorial Association, the park and recreation board, and the WPA, a two-thirds scale replica of Arlington Hall, Robert E. Lee's home in Virginia, was constructed. (02-011.)

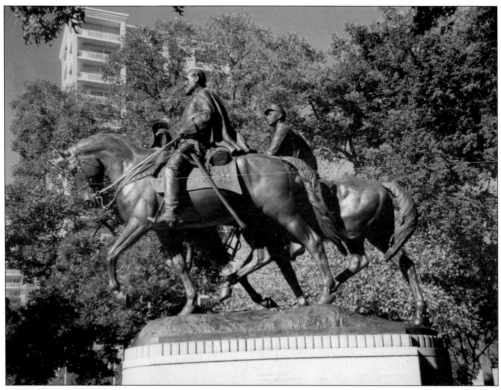

WPA park improvements in the 1930s made Lee Park a showpiece, and in recent years the park has benefited from extensive restoration and landscaping, much of it due to the efforts of the Lee Park Conservancy. Besides the Lee statue, other donations include the Memorial Fountain, which was presented to the city by the Southern Memorial Association in 1970. (03-002.)

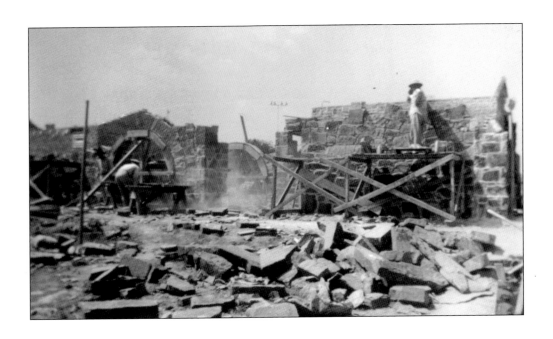

Originally purchased in 1924, Tietze Park is a beautiful neighborhood park in the M Streets area. A shelter was built in 1934, and in 1946–1947 a swimming pool building was constructed to match the park service stonework style. (03-002.)

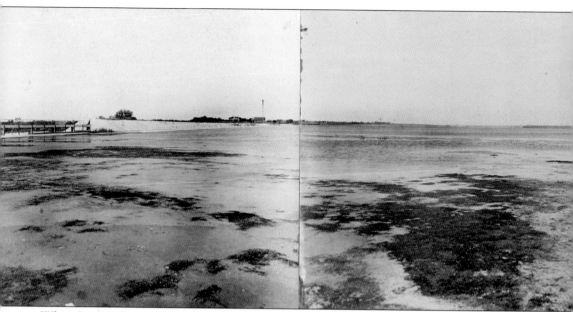

White Rock Lake is perhaps the one park in the city of Dallas to have benefited the most from New Deal funds and labor. The shoreline and grounds were transferred to the park department in 1929 for development as a park, but it had only a few amenities until the Civilian Conservation Corps began work in 1935. This panoramic view of White Rock Lake is taken from Garland Road about 1912. The pump station in the distance was finished in 1911, but the man-made reservoir had yet to fill up. (91-060.)

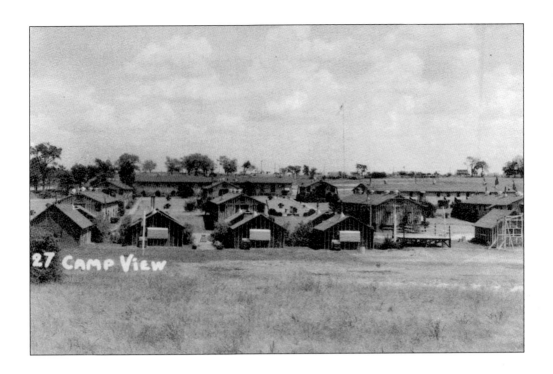

Above is the White Rock Lake Civilian Conservation Corps (CCC) camp as it appeared in the late 1930s. The camp was on the backside of Winfrey Point and housed recruits aged 18 to 25, pictured below. A formative experience for many, the "boys in green" built roads, concession buildings, community buildings, restrooms, a shelter house, and a lily pond, not to mention the thousands of trees they planted. (Kathy Smith.)

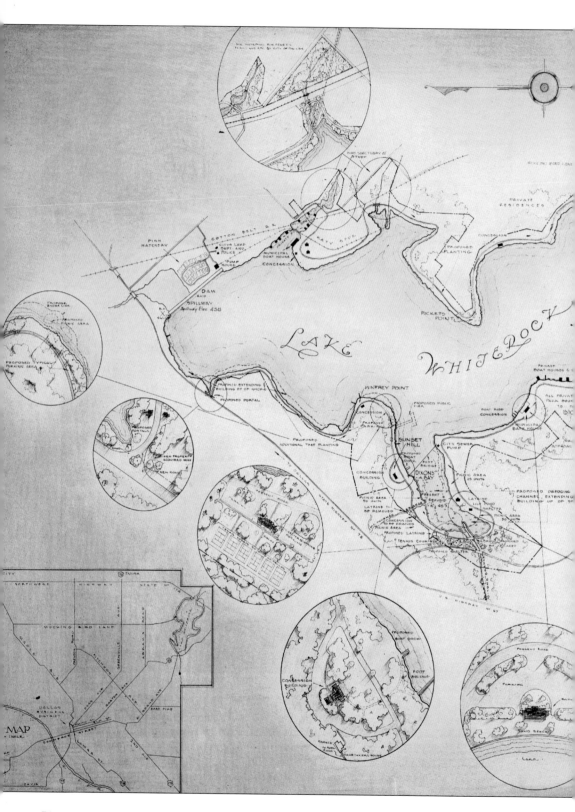

74

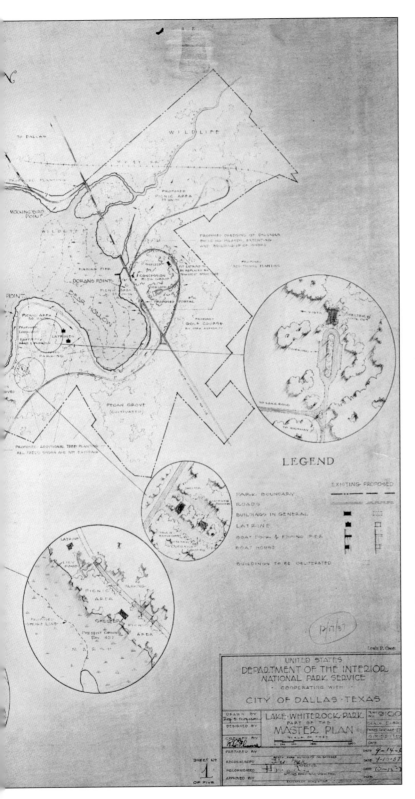

The National Park Service developed this master plan for White Rock Lake in 1937 to show the status of projects by the Civilian Conservation Corps. The detail enlargements circling the map show the placement of structures, shelters, and landscaping. (02-011.)

75

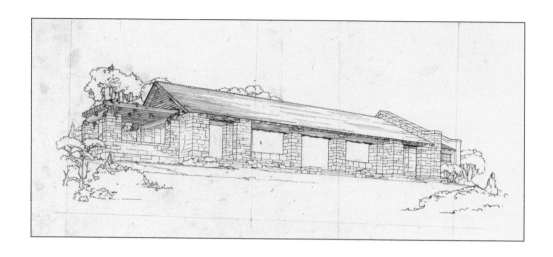

The CCC built many ruggedly beautiful structures at White Rock Lake, such as this shelter that still stands on Flagpole Hill. The architectural style is called NPS (National Park Service) Rustic. Above is the National Park Service architect's rendering from 1938, and below is the building as constructed and photographed in 1942. (02-011, 03-002.)

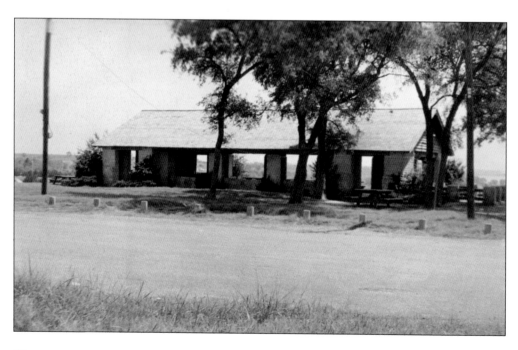

One of the concession buildings constructed by the corps at the lake was the Sunset Inn, shown above. Below is the Big Thicket, another small concession building on the east side of the lake. The building has symmetrical porches on either side of it with an alcove that looks west over the lake. The sign out front, featuring handsome woodcarving work, invites visitors for "Dinners, Drinks, Sandwiches." (03-002.)

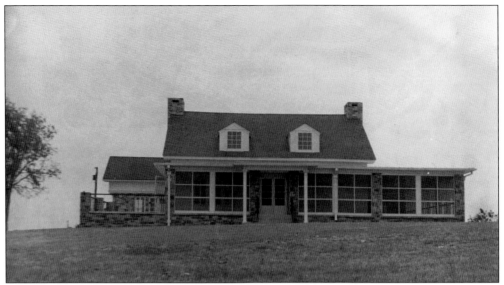

This is Winfrey Point, the last structure built by the Civilian Conservation Corps at White Rock Lake. In 1942, parks director L. B. Houston documented Winfrey and other completed work for the National Park Service with an album of photographs. (03-002.)

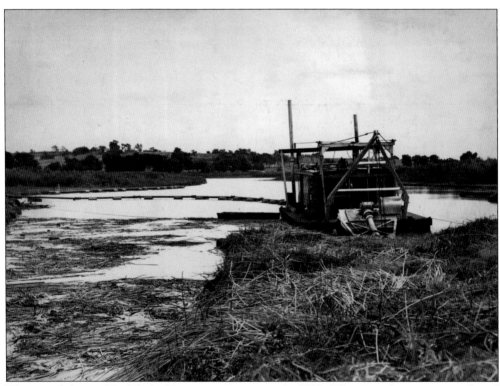

The rate of silting of the lake had been a concern since the 1920s. The water department purchased this dredge in 1937 and named it after Mayor Joe Lawther. Dredging continued until 1941 and reclaimed 68 acres at the north end of the lake and 20 acres in the Dixon Bay area. (91-060.)

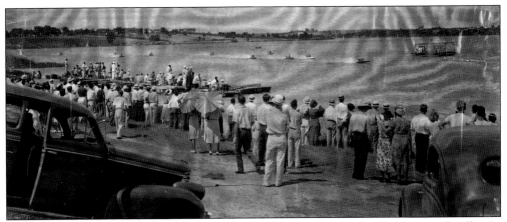

The improvement of White Rock Lake in the 1930s ensured its use by the citizens of Dallas. In this 1938 photograph, people are gathered on the shore at T and P Hill to watch the speedboat races. Across the cove on the hill is one of the lake's most famous residences, H. L. Hunt's replica of Mount Vernon. (03-002.)

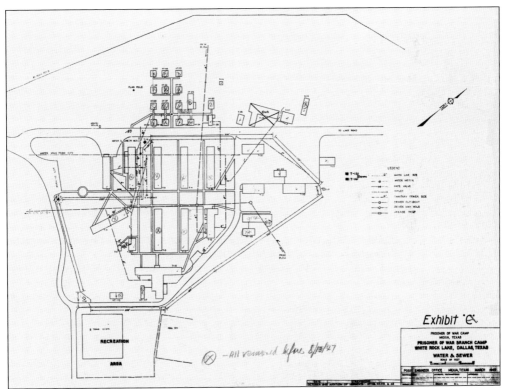

After the Civilian Conservation Corps camp closed in 1941, the barracks became a branch of the Mexia Prisoner of War Camp, housing German officers from Field Marshall Erwin Rommel's Afrika Korps. There was no enclosure around the camp, so the prisoners had to build their own fence. (02-011.)

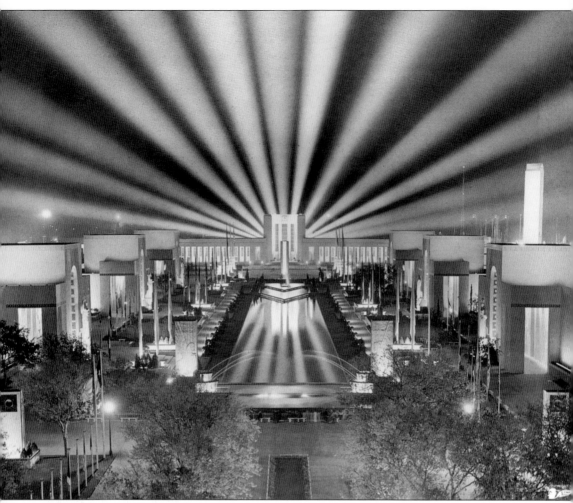

"I'm not here to talk about the past, I'm here to talk about the future. The future is Dallas, Texas." Those words from future Dallas mayor R. L. Thornton helped land the 1936 Texas Centennial Exposition in Dallas. In a sense, the centennial was in its entirety a New Deal project. Some $600 million (in 1936 dollars) in federal and state money funded much of the construction of new buildings and the renovation of older, existing buildings in Fair Park. This view shows the monumental Esplanade, which featured a nightly light show. (03-002.)

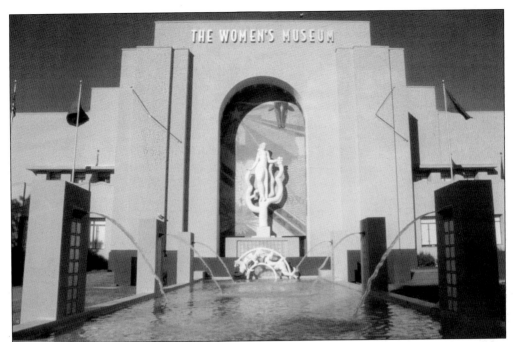

In just over 18 months, architect George Dahl worked with a talented design team to build 50 structures in the art deco style, 21 of which still stand as the largest campus of art deco buildings in the United States. Among the more unusual buildings is the former City Coliseum, which is now The Women's Museum. (Carolyn Brown.)

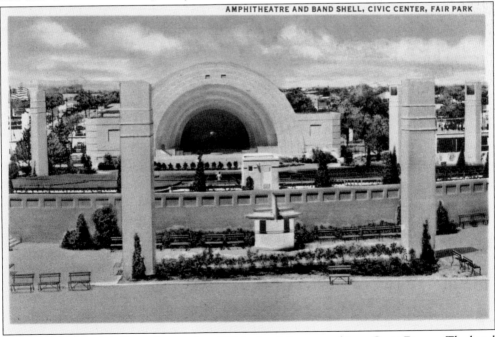

AMPHITHEATRE AND BAND SHELL, CIVIC CENTER, FAIR PARK

The Fair Park band shell was designed in 1936 by local theater architect Scott Dunne. The band shell's concentric plaster arches are reminiscent of Memphis's Overton Park and the Hollywood Bowl, and the gently sloping, 5,000-seat amphitheater is surrounded by lighting pylons. (03-002.)

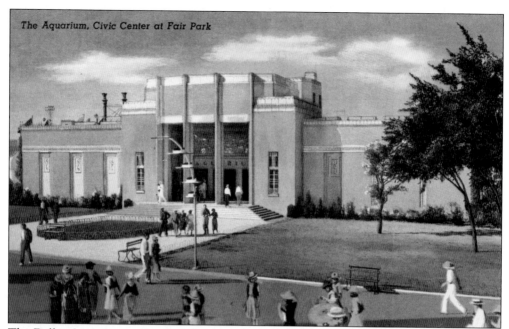

The Aquarium, Civic Center at Fair Park

The Dallas Aquarium at Fair Park has a traditional raised entrance and loggia with flanking wings and features façade elements from both the Streamline and Zigzag Moderne architectural style. Playful reliefs of sea horses and fish grace the insets. (03-002.)

The tower building, known as the Federal Building during the Texas Centennial, is a 179-foot-high triangular tower designed by Donald Nelson, who worked on the 1933 Century of Progress Exposition in Chicago. The foot of the tower features a golden eagle's head, and the grand hall in the base of the tower houses custom Heywood-Wakefield furniture. (Carolyn Brown.)

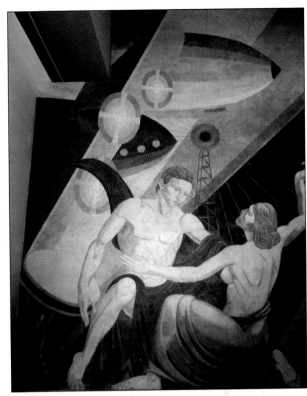

Texas Centennial–era artwork rounds out many of the 1930s buildings in Fair Park. At right is one of the many monumental murals located in the porticoes of the Centennial and Automobile Buildings that was painted by Italian artist Carlo Ciampiglia. Below is an example of the fine decorative metalwork seen throughout Fair Park. These light fixtures are in the old Museum of Natural History and were made of cast aluminum. (02-011.) One WPA-built structure that is no longer standing is the ranger station. During the Texas Centennial, Texas Rangers lived in and staffed the building. (91-011.)

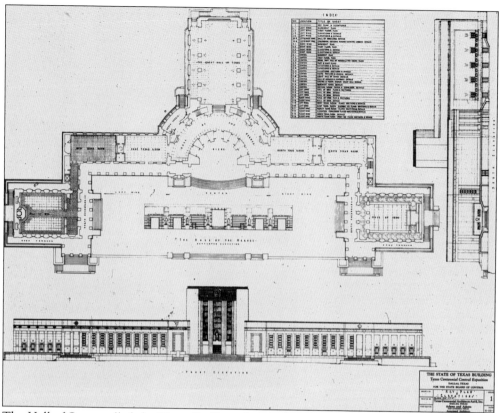

The Hall of State, called the Texas Building during the centennial, is at the terminus of the Esplanade and was the centerpiece of the exposition. Architect Donald Barthelme incorporated the classical modern style in the beautiful stone exterior, but the interiors reflecting the art, history, culture, and geography of Texas is the scene-stealer. (91-011.)

The Centennial Building, also called the Transportation Building and the Chrysler Building through the years, was originally constructed in 1905 as the first steel and masonry exhibition building in Fair Park. George Dahl's renovation in 1936 continued the earlier tripartite layout on a much grander scale. Three porticoes were added to the front, almost doubling its length. (03-002.)

84

This venerable football field started life in 1930 as Fair Park Stadium, but it was officially renamed the Cotton Bowl in 1936. It became known as "The House That Doak Built" due to the immense crowds that former Southern Methodist University running back Doak Walker drew during the late 1940s. It once was the largest stadium in the South and was the original home of the Dallas Cowboys and the Dallas Texans (renamed the Kansas City Chiefs). Below is the stadium a year or two before the centennial. (03-002.)

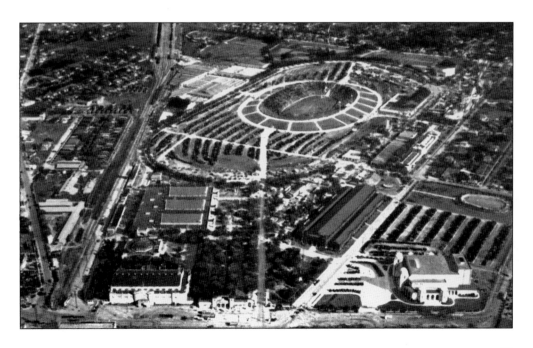

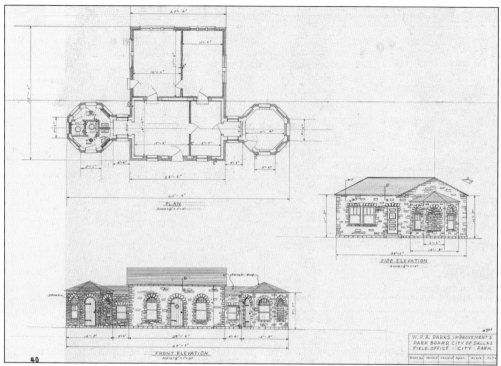

Even old City Park received New Deal improvements. This drawing shows the small but lovely field house built in 1937. It has been restored and now serves as a handsome restroom facility. (02-011.)

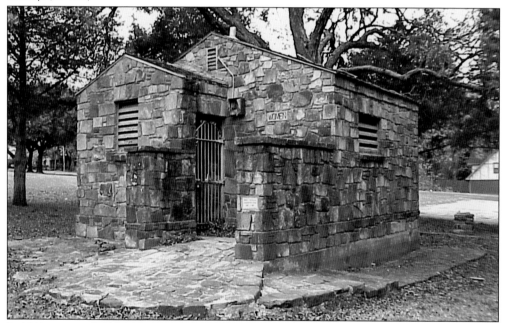

In 1941, a stone clubhouse was constructed at Tenison Golf Course with WPA and City of Dallas funds. This comfort station was built across the street at Tenison Park's picnic area along with important drainage features. (03-002.)

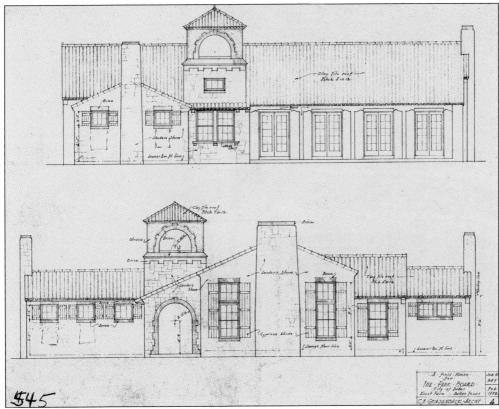

Kiest Park in Oak Cliff bears the stamp of New Deal planning and architecture. Above is Charles Griesenbeck's 1934 plan for a field house, which still stands. The shelter house, below, was designed by M. C. Kleuser and George Christensen. All three architects designed many structures in Dallas parks. (02-011.)

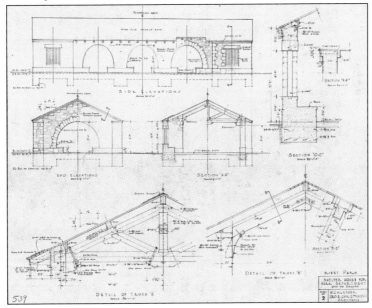

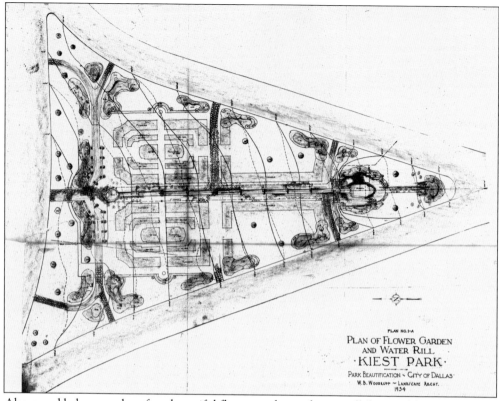

Above and below are plans for a beautiful flower garden and water rill designed for Kiest Park by Wynne Woodruff in 1934. Many of Kiest's structures were planned before there were New Deal funds, but WPA work made completion possible. (03-015.)

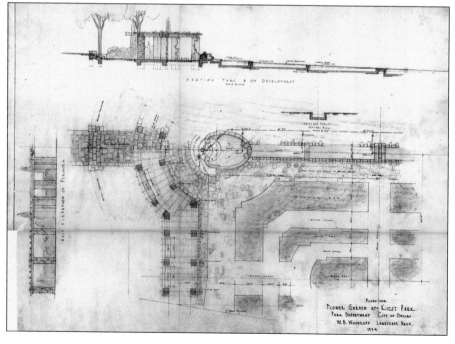

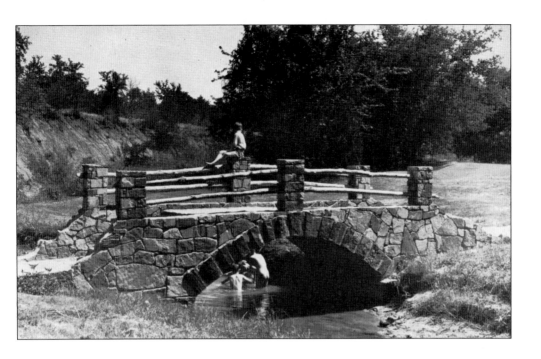

Stevens Park was already a popular golf course by the 1930s, but the WPA and National Youth Administration improvements of 1936–1939 made it even grander. These photographs of a bridge and a caddy house show off the handsome park service–style stonework. (95-023.)

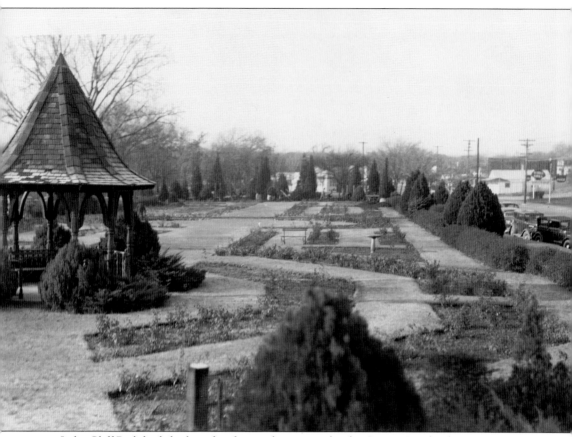

Lake Cliff Park had the benefit of an early master plan by George Kessler, but many parts were not fully realized until the WPA additions. The agency built a roque court, picnic units, a bridge, walkways, a garden, a fountain, a retaining wall, and did extensive landscaping. (95-043.)

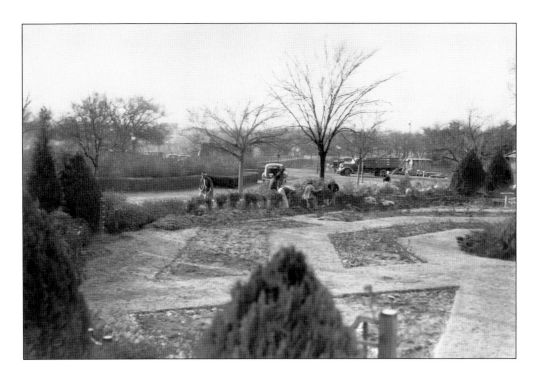

Perhaps most important among the WPA's touches was the reinvention of the formal rose garden, originally installed in 1934. In these photographs from the winter of 1940–1941, WPA relief workers are building the new rose garden and landscaping the park. (95-043.)

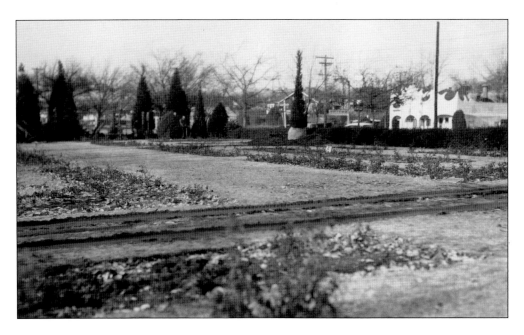

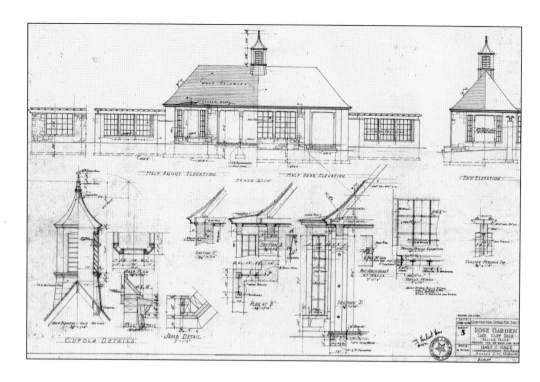

Although the WPA did the construction work, the design was done by Hare and Hare of Kansas City, who not only designed the rose garden but also a handsome pergola wrapping around it. The garden was restored by the Friends of Oak Cliff Parks and the pergola by the park and recreation department. (02-011.)

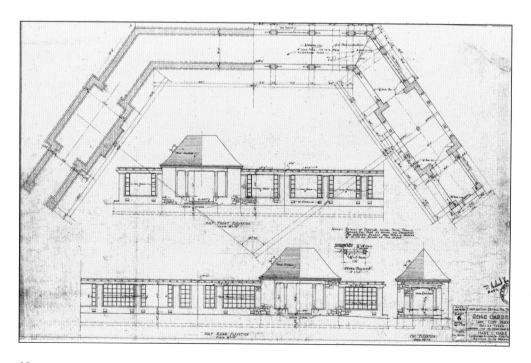

Four

A Metropolitan Park System

Dallas's population exploded during World War II and immediately after, when the aircraft industry, a Ford plant, and other employers settled in Dallas. The Dallas park system expanded accordingly, adding more parks, playgrounds, and swimming pools for the expanding city limits and its neighborhoods. In the days when television was a novelty and decades before computers and the Internet, free or affordable physical recreation and entertainment were extremely important parts of the fabric of Dallas culture. For example, in the late 1940s, visitors to Dallas parks regularly totaled over 12 million each year.

The Dallas Park and Recreation Department was a pioneer in applying Maslow's hierarchy of needs to parks and recreation centers, whereby the park's offerings were tailored to the most important needs of a neighborhood. The park system's community houses from the 1920s through the 1940s, and their later incarnation—recreation centers—have at one time or another provided all kinds of social services, such as vocational training, after-school programs, health clinics, and sometimes just a place to shower. Play and recreation as healthy activity was encouraged through organized sports and citywide leagues. This chapter explores the later historic parks of Dallas and their reach throughout the entire city of Dallas.

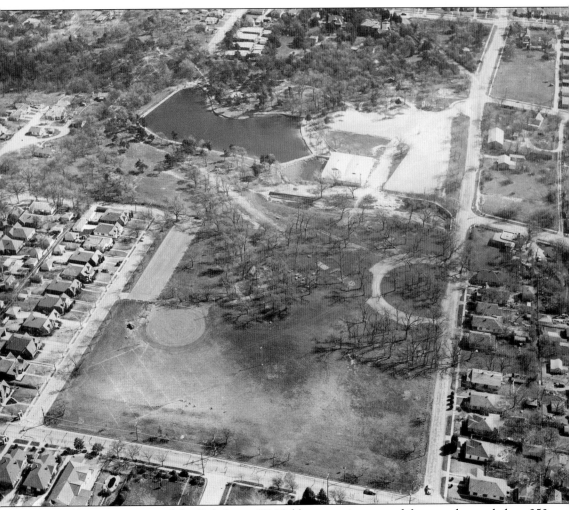

Kidd Springs is named for Col. James W. Kidd, an auctioneer and farmer who settled on 250 acres in the Oak Cliff area. Colonel Kidd's farm was literally an oasis on account of the natural springs that ran through it. It had beginnings as a private park in 1895 as the Kidd Springs Fishing and Boating Club. This aerial photograph was made in 1954, seven years after the property was acquired by the city. (03-002.)

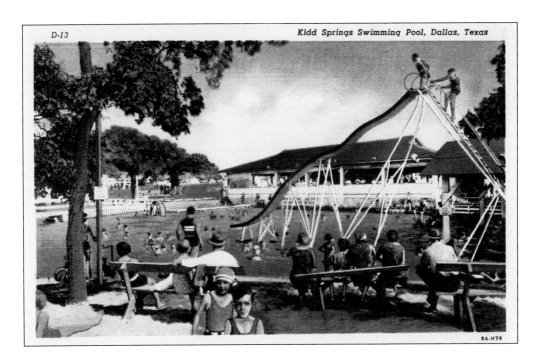

Above, a postcard shows the springs of Kidd Springs as they would have appeared in the late 1930s. Below is Hare and Hare's preliminary landscaping plan from 1954. Today the park has the same little lake and has a steady stream of visitors young and old. It offers a recreation center, a butterfly garden, shaded walking paths, and a playground area. (03-002, 02-011.)

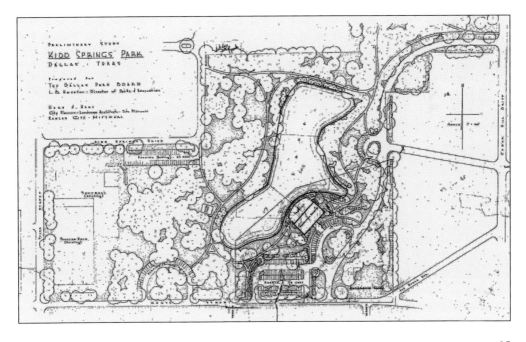

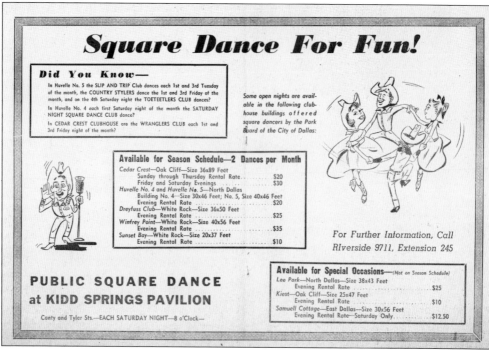

Dallas parks became the epicenter of the national square-dancing phenomenon of the late 1940s and early 1950s, providing space for the highly competitive dance form. The Kidd Springs Pavilion attracted dancers from across the Southwest. (03-002.)

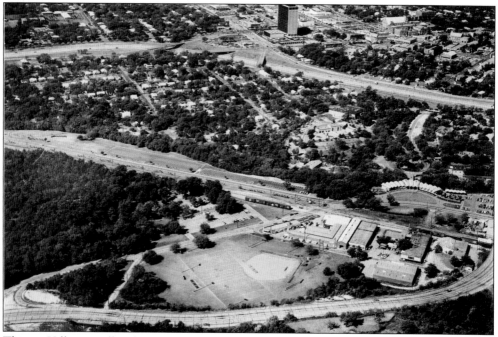

Thomas Hill is a small park in Oak Cliff that contains a portion of the Dallas Zoo. It was acquired in 1945–1947 from the Thomas family, and a portion of it was used for constructing the Marsalis Avenue overpass. (03-002.)

Hattie Rankin Moore Park was acquired in 1949 through a donation by the Dallas Board of City Missions of the Methodist Church. This park hosted the first municipal swimming pool in West Dallas and was an important addition to an impoverished area, which then had little in the way of parks and recreational amenities. (03-002.)

Originally developed as a private country club, Cedar Crest Golf Course opened in 1916. In 1927, the course played host to the first PGA Championship to be played in the South, where legend has it that a young Byron Nelson caddied for the championship winner Jim Turnesa. During the Depression, the course was purchased by the Schoellkopf family, who sold the property to the city in 1946. At that time, it became the city's third municipal golf course after Tenison and Stevens Park. At left is the course in 1954. Below is probably the oldest existing map of the course from 1923. (03-002, 02-011.)

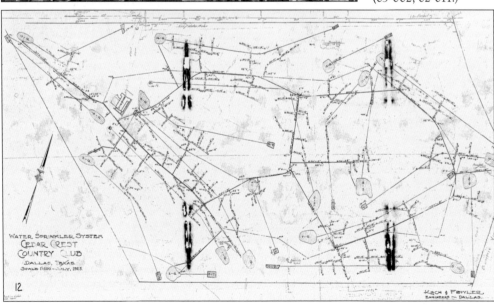

WATER SPRINKLER SYSTEM
CEDAR CREST
COUNTRY CLUB
DALLAS, TEXAS
SCALE 1:100 — JULY, 1923.

KOCH & FOWLER
ENGINEERS — DALLAS.

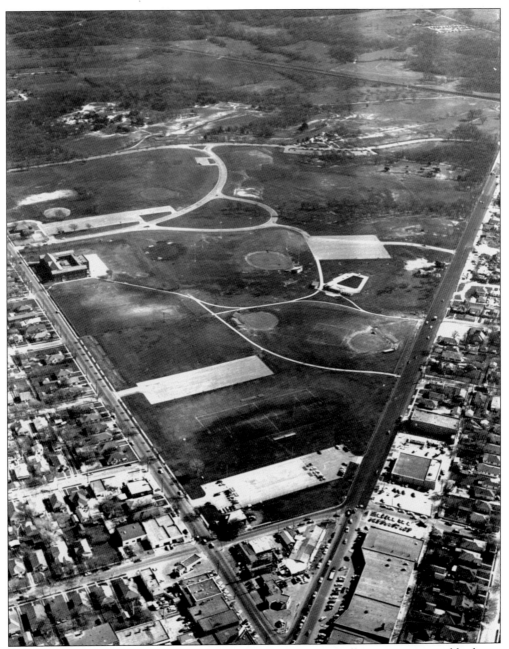

Upon Dr. W. W. Samuell's sudden death in 1938, a handwritten will on a prescription blank was discovered, reading simply, "Real estate to the City of Dallas Park Board for park purposes—not to be sold. Balance to Park Board as permanent foundation. First National Bank, administrator." After the will's probation, $1,222,000 was awarded to the Dallas Park and Recreation Department, along with approximately 900 acres of developed and undeveloped property. Samuell's gift is the largest single donation to the park department and was for many years one of the largest bequests ever made to the City of Dallas. This aerial view shows what is now called Samuell Grand Park for its proximity to Grand Avenue. Dr. Samuell's homestead was itself on the grounds until it was demolished. There are several parks in Dallas bearing his name. (03-002.)

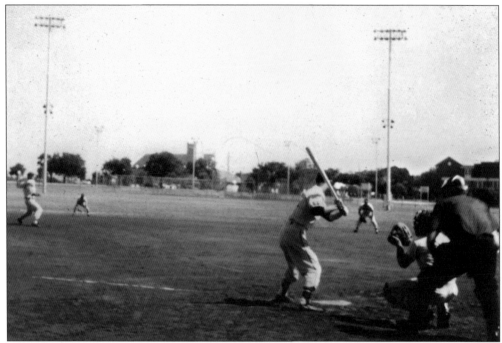

Located adjacent to Tenison Golf Course, Samuell Grand Park's more than 100 acres makes it one of the largest parks in the system. Manpower shortages during World War II and building restrictions during the Korean War prevented significant development of the park until 1953. These delays allowed the park board to develop extensive plans that resulted in an outstanding neighborhood park. The final plans included lighted baseball and softball diamonds, a large swimming pool, a complex of 20 lighted tennis courts, as well as extensive landscaping. The park also plays host each summer to the Shakespeare in the Park festival. Above are baseball players on the diamond about 1954. Below is a view of the traffic at the Davis Cup Americas Zone Final tournament in 1965; the United States beat Mexico 4–1. (03-002.)

Another of Dr. Samuell's parcels became Samuell Garland Park. Located in the suburb of Garland, Texas, on McCree Road near Interstate 635, this former farm lost acreage due to the expansion of the Santa Fe Railroad as well as the construction of Loop 635. This is how it looked in 1959. (03-002.)

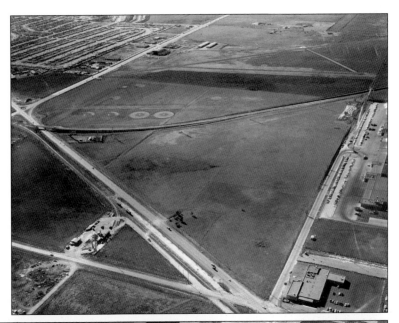

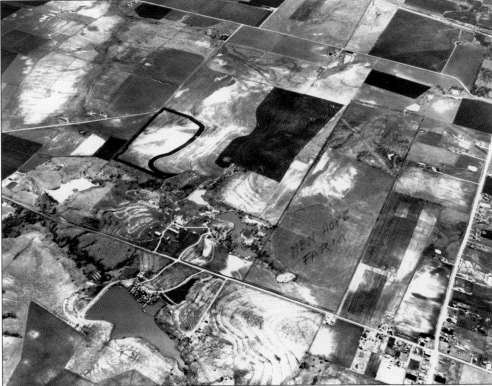

Also part of the original bequest from Dr. Samuell, Samuel New Hope Park was kept for agricultural use and leased by the city to local farmers. The property, seen here in 1955, remained farmland until the city grew large enough to make appropriate use of the acreage. Located near the town of Sunnyvale, the park is within the bounds of what had once been the small farming community of New Hope, where Dr. Samuell's family settled when he was a child. (03-002.)

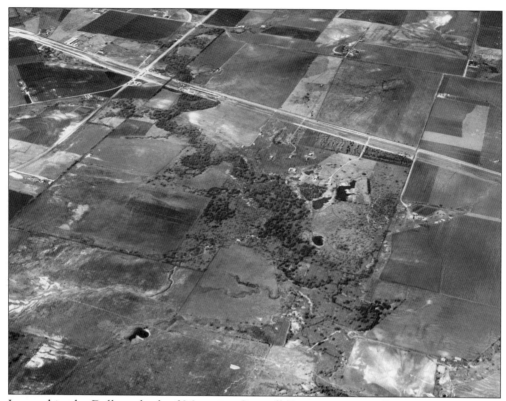

Located in the Dallas suburb of Mesquite, Samuell Farm was originally a 492-acre working farmstead that Dr. Samuell received in lieu of payment for his services. It was his intention that the farm be used to grow feed for animals housed at the Dallas Zoo. In 1958, the city purchased an additional 22 acres. Though no longer a producing farm, the park maintains much of its agricultural character, including orchards, stock ponds, and displays of farming implements, and is intended to educate urban residents about rural life. (03-002.)

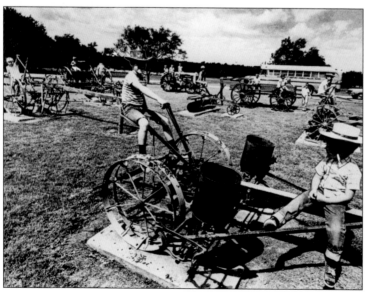

Kids enjoy a day at Samuell Farm playing on vintage farming implements. (03-002.)

Farmers work Samuell Farm sometime during the late 1950s. Dallas and North Texas was in the midst of a catastrophic drought during this time. (03-002.)

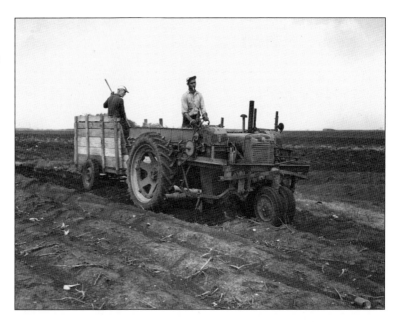

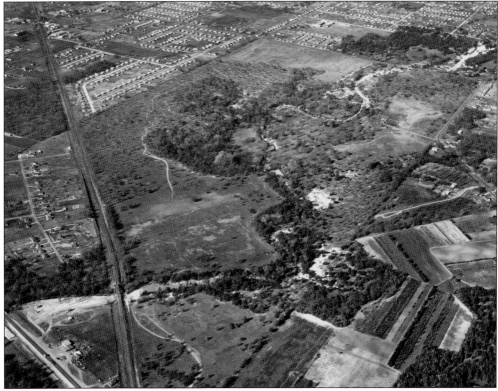

Crawford Memorial Park is located at Elam Road and Old Seagoville Road. This park was given to the city in 1954 by William Crawford in memory of his parents. Legend has it that the caves that dot the creek running through the park were a hideout for local outlaw Belle Starr, who was raised in nearby Scyene. (03-002.)

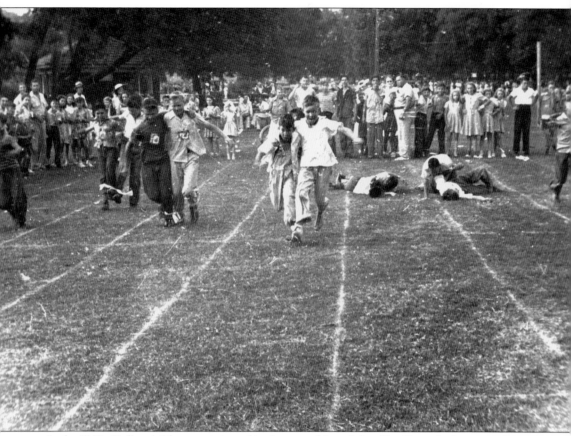

In the 1940s, Dallas children participated in the annual Joseph Lee Play Day, which was proclaimed by Pres. Franklin Roosevelt in honor of the founder of the modern recreation movement. Here children from all over the city converged on Reverchon Park to compete in races, team sports, and pageants. This photograph is from 1943. (03-002.)

These two photographs show children from all over the city engaging in Joseph Lee events at Reverchon in 1943. (03-002.)

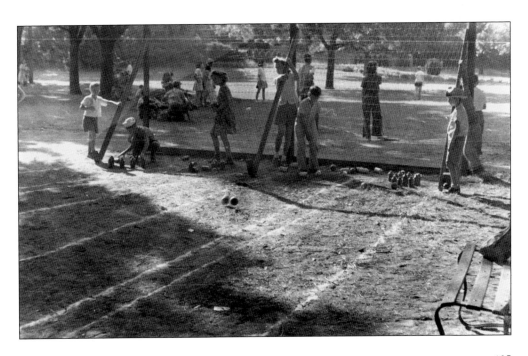

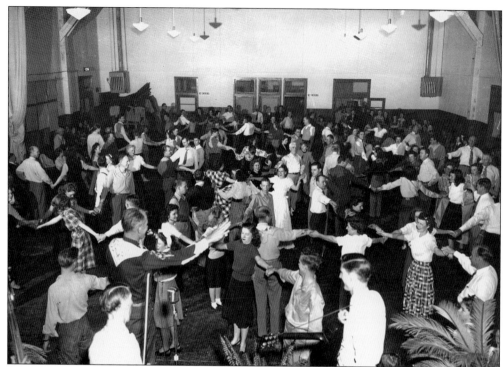

The Dallas Park Department also provided recreation activities in places that did not have formal parks. During the 1940s and 1950s, a housing shortage led to the construction of several federal housing projects in the Oak Cliff area. La Reunion, Mustang Village, and the Texan Courts sprang up off Fort Worth Avenue. Above is a square dance at La Reunion Place about 1950. Below is another dance at the Texan Courts in 1945. (03-002.)

Exline Park in South Dallas featured events for different age groups during the 1950s. The winners of a junior talent show are shown above, and a teen dance at Exline is below. (03-002.)

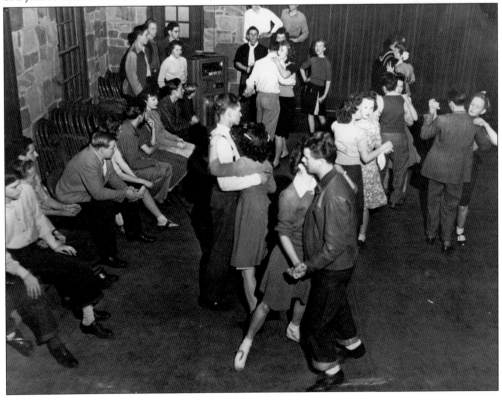

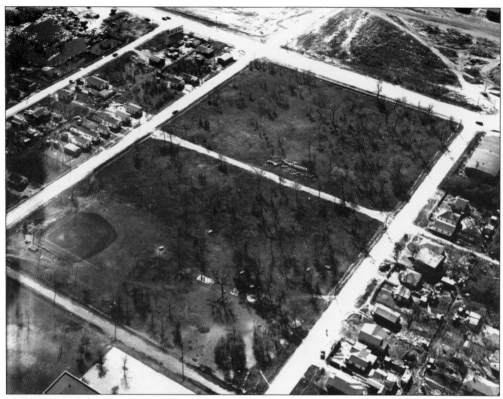

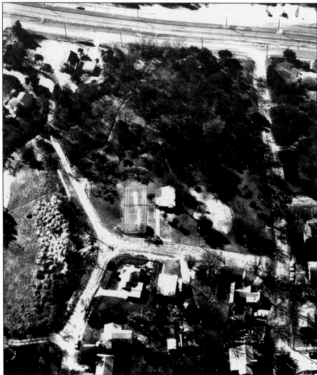

Nash Davis Park, originally North Hampton Park, was acquired in 1944. Situated near the West Dallas Housing Project, the park amenities included a junior pool, as well as lighted baseball and softball diamonds. This park received one of the first modern recreation centers built by the city in a disadvantaged neighborhood. This is Nash Davis long before the pool and the recreation center. (03-002.)

Urbandale, a 3-acre park, became part of the park and recreation department when the unincorporated community of Urbandale was annexed by Dallas in 1945. The roof of Urbandale's former city hall is just to the right of the tennis court. (03-002.)

Moss Park (not to be confused with a later Harry Moss Park) in Oak Cliff was used as a reservoir before the property was transferred to the park department in 1930 for development as a city park. It had no basketball facilities, so the kids played at Compton Citadel on Corinth Street. The Salvation Army sponsored these boys, who pose for a photograph here in 1938. (03-002.)

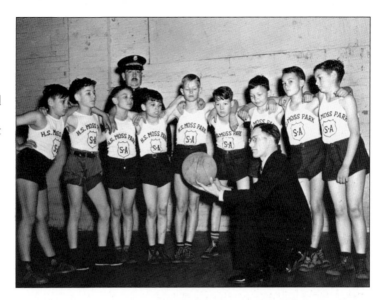

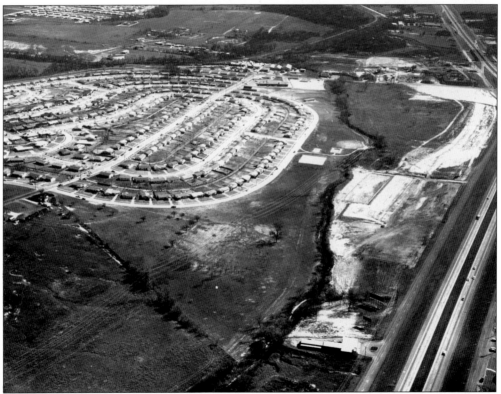

Hamilton Park, located in North Dallas near Central Expressway and Forest Lane, was formerly known as Willowdell Park. It was purchased from the Dallas Citizens Interracial Association, who had purchased 233 acres for development as the city's first subdivision designed exclusively for African American residents as a means of relieving the city's minority housing shortage. The subdivision, also called Hamilton Park, opened in 1954. The area was named for Dr. Richard T. Hamilton, an African American civic leader and physician. (03-002.)

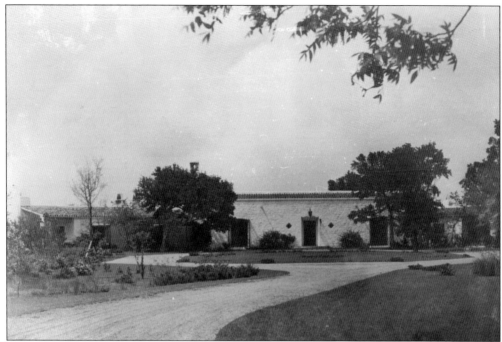

The Dallas Arboretum is operated on the grounds of the Everette DeGolyer home, a city park purchased in 1975. In 1936, Everette and Nell DeGolyer hired California architects Denman Scott and Burton Schutt to design their new home overlooking White Rock Lake. Exhibiting outstanding features of the Spanish colonial revival style, Rancho Encinal was completed in 1940. Noted landscape architect Arthur Berger planned the grounds of the estate to complement its natural surroundings. Following the DeGolyers' deaths, their foundation donated the house, grounds, and library to Southern Methodist University. The university then offered it to the City of Dallas. Here are two views of Rancho Encinal at the time of construction. (95-030.)

Five

DALLAS PARKS AND THEIR HISTORIC NAMESAKES

Many Dallasites and visitors spend days, and even lifetimes, at parks without questioning the story behind a park's name. There are obvious reasons for names such as Martin Luther King Jr. or such geographical names as Cedar Crest, Lake Cliff, or Bachman. But there are also many other parks that contain stories of adventure, the immigrant experience, the Old West, and the communities that were once separate from Dallas but now are neighborhoods within the city limits. Finally, there are parks that honor men and women who have had an impact on Dallas and, in particular, on the park system. Some names like Reverchon and Fishtrap invoke thoughts of the Fourierist utopian commune, La Reunion, which brought to early Dallas people from Belgium, France, and Switzerland. Dallas park names also reflect the diversity of cultures that have made their way in "Big D" for well over 150 years. The following chapter explores just a few of these fascinating people and places.

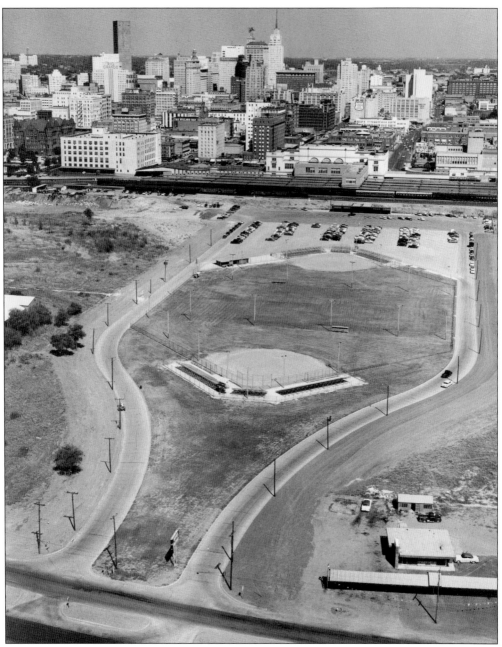

Union Terminal Park no longer exists, but the building it is named for does. Purchased in 1946, the park was directly behind the Union Terminal on Houston Street. It had a baseball diamond and a pedestrian tunnel leading underneath the rail yard into the station. Its life was short, for the Texas Turnpike Authority announced a new section of Interstate 35 would run right through the park. It was dismantled in 1956 and thus disappeared into history. (03-002.)

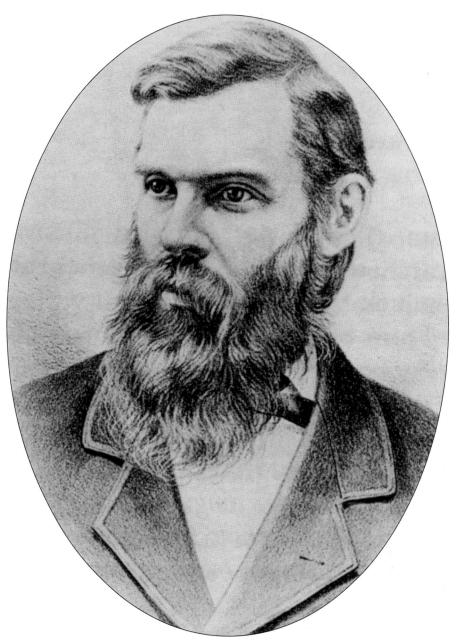

Reverchon Park is named for a noted botanist. Born in Diemoz, France, in 1834, Julien Reverchon immigrated to Texas with his father in 1856 and settled in the French utopian community of La Reunion, located in present-day Oak Cliff. Reverchon remained there until the colony's failure a few years later and then moved to the small community of Dallas. Already a well-educated botanist at the age of 18 when he arrived in Texas, he turned his attention to the flora and fauna of the region, collecting and identifying samples and corresponding with well-known botanists around the world. After contributing articles concerning his finds to many of the top scientific journals of the day, Reverchon was honored by having several species named after him. He later became a professor of botany at Baylor University College of Medicine and Pharmacy. He died in 1905. (03-002.)

Celebration of Life Park is a small urban park at 600 Pearl Street. In 1981, the R. A. Bloch Cancer Foundation, connected to the H&R Block tax preparation firm, developed a small park to be named Richard and Annette Bloch Cancer Survivors Park. Dedicated to Americans who have been diagnosed with cancer, the park represents a tribute to life. Since then, 19 additional cancer survivor parks have been created throughout the country. The Dallas park features life-sized bronze sculptures representing the wide variety of people who successfully fight cancer each year. The Dallas Park Board later voted to change the name to Celebration of Life Park. (03-002.)

The Martin Luther King Jr. Community Center was created out of the August 1967 Crossroads Community Center bond issue in which funds were set aside for a multipurpose service center in South Dallas. The center has offered medical, employment, and welfare assistance, neighborhood and housing improvement, and day care for children. Construction began in 1970, and the new complex was dedicated in 1975 after having been renamed for Dr. Martin Luther King Jr. (99-003.)

A Swiss immigrant and barber, Emil Fretz was appointed to the first park board in 1905. His appointment began a 22-year career in public service that extended into his retirement years. One of the major accomplishments during his tenure was the establishment of Trinity Play Park in the disadvantaged area known as the Cotton Mills. The park board believed that the establishment of parks, playgrounds, and activity centers in underprivileged neighborhoods could help alleviate crime and violence. Upon his retirement from the board in 1927, Trinity Play Park was renamed Fretz Park in his honor. A second Fretz "North" Park opened in 1964, and after the first one was closed it became the sole Fretz. (96-003.)

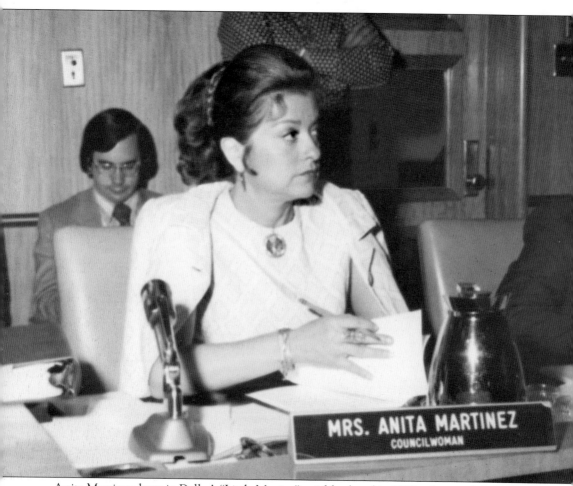

MRS. ANITA MARTINEZ
COUNCILWOMAN

Anita Martinez, born in Dallas's "Little Mexico" neighborhood in 1925 to José and Anita Nañez, was the fifth of six children. After graduating from Crozier Tech High School, she married Alfred Martinez, son of the founder of the El Fenix restaurant chain. Always an active member of her community, Anita Martinez was approached to run for Dallas City Council in 1969. Elected to represent her former West Dallas neighborhood, she was the first Hispanic to serve on the Dallas City Council, serving from 1969 to 1973. Among her accomplishments while serving on the city council and as a private citizen are the establishment of the Anita Martinez Recreation Center in West Dallas, the opening of Los Barrios Unidos Clinic, and the formation of the Anita N. Martinez Ballet Folklorico, an organization dedicated to instilling cultural pride and awareness in the Hispanic community while educating the general public regarding the contributions the Hispanic community has made to society. (99-003.)

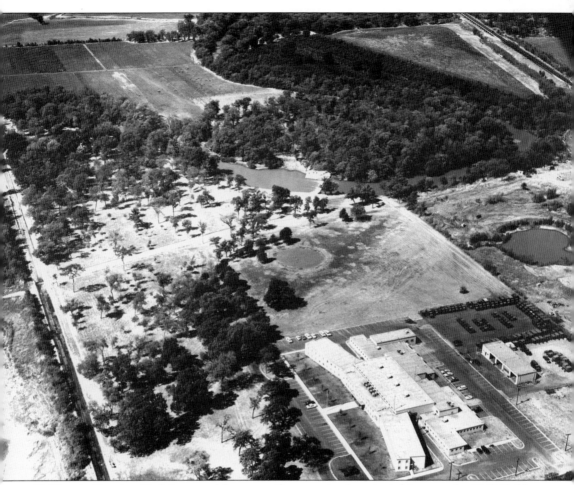

California Crossing Park is named for a specific event in American history—the 1849 Gold Rush—with a local connection. Here thousands of '49ers crossed the Trinity River in a trek west following the California gold discovery. The crossing was at a ford on the shallow part of a stream on Southern transcontinental route to the Pacific. Later the crossing was used by stage lines and railroads passing through Dallas and Cedar Springs on to El Paso. (03-002.)

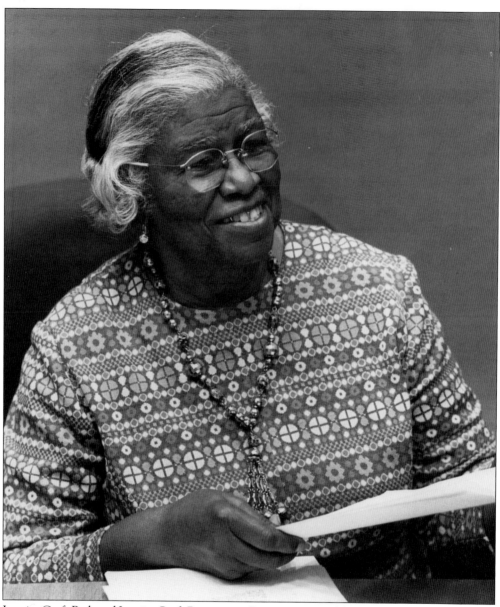

Juanita Craft Park and Juanita Craft Recreation Center are named for Juanita Jewel Shanks Craft (1902–1985), an American civil rights pioneer and member of the Dallas City Council. Born in Round Rock, Texas, Craft came to Dallas in 1925. She joined the NAACP in 1935, eventually becoming the Texas NAACP field organizer in 1946. She helped to organize 182 branches of the NAACP over 11 years. In 1944, she became the first African American woman in Dallas County to vote in a public election. She helped organize protests and pickets in segregated lunch counters, restaurants, theaters, and public transportation, and worked to integrate the Dallas Independent School District. She later served two terms on the Dallas City Council from 1975 to 1977 and again from 1979 to 1980. Her home on Warren Avenue in South Dallas is now the Juanita J. Craft Civil Rights House, also a park property. Many historic figures climbed the wooden steps of its front porch seeking audience with Craft, including Martin Luther King Jr. and Pres. Lyndon B. Johnson. (99-003.)

Tietze Park is named for William R. Tietze, a longtime superintendent of parks for the city from 1896 to 1933. Tietze was born in New Braunfels, Texas, in 1859, the son of German immigrants. Tietze's tenure with the Dallas Park and Recreation Department began when there was just one park and ended 36 years later when the system had grown to 50. His professional interest in the cultivation of flowers and plants started after serving for two years as a horticulturalist for Henry Shaw, philanthropist and founder of the Missouri Botanical Gardens in Saint Louis. (95-025.)

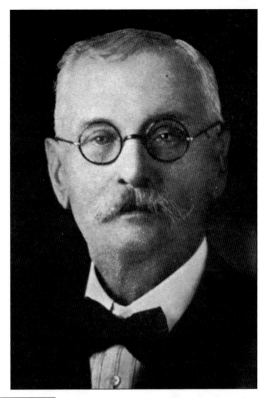

Hattie Rankin Moore Park's namesake was better known in Dallas as "Miss Hattie." Moore (1879–1953) was a born reformer. Her crusade for parks for West Dallas began after seeing a picture of Raymond Hamilton, the notorious member of Clyde Barrow's gang and native of the West Dallas slums, on death row. Learning about the rough life of West Dallas youth with no recreational opportunities, she protested, "Folks wonder why so many West Dallas boys turn out to be criminals. . . . They haven't a dog's chance to be anything else. We have no parks, no playgrounds, no handy schools, no lights, no water, no gas. . . . The dogs in Dallas are housed better than our boys and girls." Moore's missionary zeal resulted in more schools, churches, and parks in the area. In 1949, Hattie Rankin Moore Park was dedicated in her honor. (95-023.)

The "Nash" in Nash Davis Park and Recreation Center is named for Mattie Lee Nash. Former Dallas City council member Mattie Lee Nash came to Dallas from the Corsicana area and is a longtime public housing advocate. A homemaker who represented portions of West, North, and South Dallas in District Six, her early political and social career involved launching petition drives to bring water, sewer service, paving, and gas to her neighborhood. An early voter registration campaigner, Nash fought to improve housing while chairing the council's housing committee. She also served on the Dallas Housing Authority Board of Directors, the Dallas County Community Action Agency, and the Dallas County Democratic Women's Club. (92-017.)

Martin Weiss (1865–1957) was a native of Vecs, in Hungary's Carpathian Mountains, who immigrated to the United States with little more than dreams and the clothes on his back. After some time in New York, he started over at age 46, moving to Dallas and opening a millinery business. An extremely successful businessman, Weiss and his wife shared their prosperity with the rest of Dallas and were behind the building of Dealey Plaza and Methodist Hospital. They also purchased the land where Martin Weiss Park and Recreation Center stands today. (92-018.)

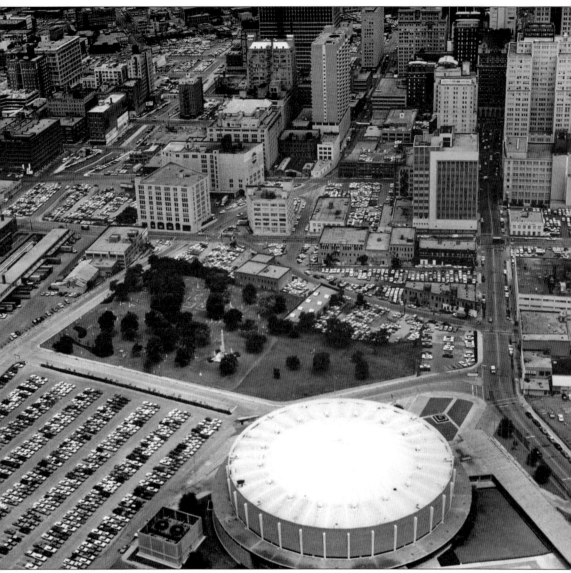

Located next to the Dallas Convention Center, what is now known as Pioneer Park Cemetery was established by the Masonic and Odd Fellows fraternal organizations in 1857. The cemetery is the final resting place of numerous early Dallas civic and business leaders, including entrepreneur Sarah Horton Cockrell, early Dallas mayors John Crockett, Dr. J. W. Crowdus, and John Jay Good, and publisher J. W. Latimer. In 1961, the Confederate Memorial at City Park was moved to Pioneer Park Cemetery to save it from destruction when R. L. Thornton Expressway was built through a portion of City Park. (03-002.)

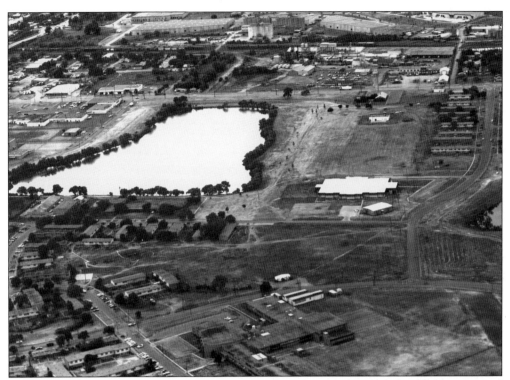

Fishtrap Cemetery (also called the La Reunion Cemetery) and Fish Trap Lake, both maintained by the park department, are connected to a historic colony. French, Belgian, and Swiss settlers immigrated to this area from 1855 to 1858 and established the utopian community La Reunion. The cemetery was on the road from La Reunion to the area of willow fish traps set by the colonists in the Trinity River. The colony failed, but certain families remained, including the Loupots, Remonds, Reverchons, and Santerres. They became business land cultural leaders in Dallas area and used this cemetery for family burials as late as 1939. Fish Trap Lake, also called West Dallas Housing Project Lake, was created by damming part of the West Fork of the Trinity River and was completed in 1958. (03-002.)

Eloise Lundy Park and Recreation Center are named for one of the first African American park and recreation leaders to work for the Works Progress Administration in Dallas during the Great Depression. In the 1940s, Eloise Lundy joined the Dallas Parks Department. She was promoted from recreation leader to area supervisor and later became district supervisor for about 45 parks. In 1987, Oak Cliff Park was named for her contributions to generations of Dallas citizens. Lundy was a motivator and a hands-on instructor and played ping-pong, checkers, dominoes, and horseshoes with children at the recreation centers. Even after retirement in 1974 she remained active, teaching ceramics up to the age of 89. (03-002.)

Dr. W. W. Samuell was the single largest benefactor of the park department. William Worthington Samuell was born in Kentucky in 1878. His family moved to the New Hope, Texas, area and he was educated in Dallas public schools. He attended the University of Texas and took his medical degree from Tulane University. A nationally respected surgeon, he established the Samuell Clinic in Dallas and died suddenly in 1937 at age 59. A golfing, hunting, and fishing enthusiast, he bequeathed over 900 acres of land to the City of Dallas and helped pave the way for a verdant, expansive park system.

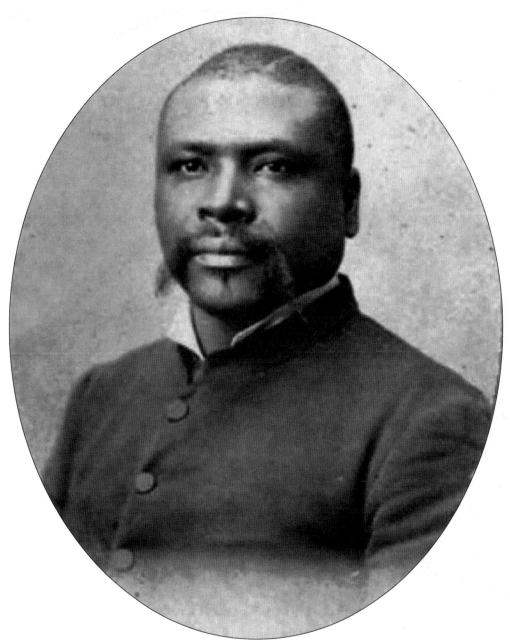

Dallas has a park named for a dynamic African American minister. Allen R. Griggs was born a slave in Georgia about 1850 and was brought to Texas at age nine. Griggs joined the Baptist Church in 1869 and was ordained soon after. In the early 1870s, Griggs received his first pastorate at the New Hope Baptist Church in Dallas and later served as pastor at Mount Gilead Baptist Church in Fort Worth and First Baptist Church in Chattanooga, Tennessee. Reverend Griggs helped raise funds to establish Bishop College and was a cofounder of North Texas Baptist College in Denison. He is also credited with establishing the first African American high school, as well as newspaper, in Texas. In 1891, the State University of Kentucky awarded an honorary doctor of divinity degree to Griggs. At the time of his death in 1922, he was dean of North Texas Baptist College in Denison. His son Sutton Griggs was an equally dynamic minister and novelist. (03-002.)

Tenison Golf Course and Park were named in memory of the son of Edward O. and Annie Tenison, who died in World War I. E. O. Tenison started as a messenger in a bank as a 13-year-old and by 1903 was a bank president. He ascended to national prominence when he masterminded the organization of the Federal Reserve Bank of Dallas. On land donated by Mr. and Mrs. Tenison in 1924, Tenison Glen became Dallas's first municipally owned golf course. Thousands of Dallasites, from beginners to aspiring tour professionals like Lee Trevino, have developed their passion for golf on the park's tree-lined fairways. (95-025.)

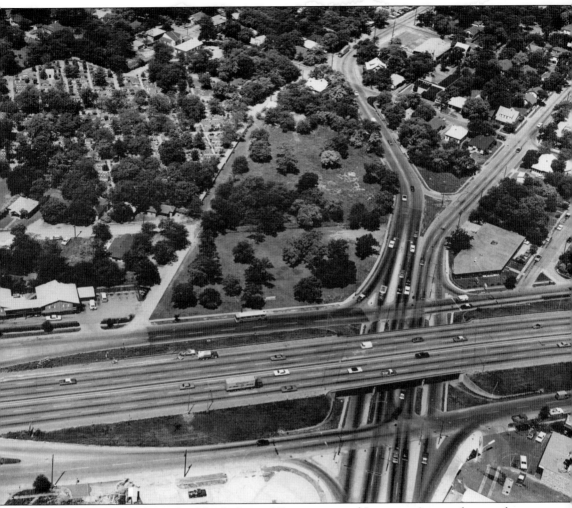

Freedmen's Cemetery, located at North Central Expressway and Lemmon Avenue, honors the early African American residents of Dallas. This area of the city, called Freedmen's Town, was settled by former slaves shortly after the Civil War. Freedman's Cemetery, a graveyard for African Americans, was established in 1869 on 1 acre of land with an addition of 3 acres. Thoughtless planning and construction of the Central Expressway through this area in the 1950s destroyed much of the aboveground reminders of the cemetery. Descendants of persons buried here and the City of Dallas agreed in 1965 to establish the Freedman's Memorial Park and Cemetery. Beginning in 1989, community representatives worked with the city and the Texas Department of Transportation to preserve the historic Freedman's Cemetery site prior to further highway expansion. The park now features a formal entrance with statuary by sculptor David Newton. (03-002.)

www.arcadiapublishing.com

Discover books about the town where you grew up, the cities where your friends and families live, the town where your parents met, or even that retirement spot you've been dreaming about. Our Web site provides history lovers with exclusive deals, advanced notification about new titles, e-mail alerts of author events, and much more.

Arcadia Publishing, the leading local history publisher in the United States, is committed to making history accessible and meaningful through publishing books that celebrate and preserve the heritage of America's people and places. Consistent with our mission to preserve history on a local level, this book was printed in South Carolina on American-made paper and manufactured entirely in the United States.

This book carries the accredited Forest Stewardship Council (FSC) label and is printed on 100 percent FSC-certified paper. Products carrying the FSC label are independently certified to assure consumers that they come from forests that are managed to meet the social, economic, and ecological needs of present and future generations.

FSC
Mixed Sources
Product group from well-managed
forests and other controlled sources

Cert no. SW-COC-001530
www.fsc.org
© 1996 Forest Stewardship Council

Find Your Place in History.